IMAGES
of America

HUBBARD PARK

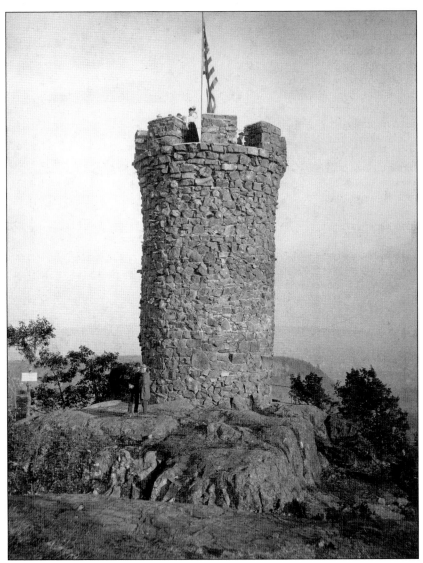

Three Cheers for Walter Hubbard. During the October 29, 1900, dedication of Hubbard Park, a large flag was raised at noon above Castle Craig Tower (then known simply as the Tower) by Hubbard's contractor Patrick Quigley. As it flew in the breeze, three rousing cheers were given. This flag had historic associations. It was shot down during the War of the Rebellion, and years later, it was raised over the Hawaiian capital of Honolulu. When the Republic of Hawai'i was proclaimed during Pres. Grover Cleveland's administration, there was an unsuccessful attempt to haul this flag down by the rebellious subjects of Queen Liliuokalani. It is unknown how the flag came into the possession of Hubbard or of the City of Meriden. (Courtesy of the Meriden Historical Society.)

On the Cover: Hubbard Park Grecian Temple. In this early 1900s photograph, three Meriden spectators observe an automobile circling the turnaround and floral garden in front of the Hubbard Park Grecian Temple. The image also captures the immaculate landscaping of the park and the crisp, trimmed roadways of crushed stone that characterized the lower park. (Courtesy of Allen Weathers.)

IMAGES
of America

HUBBARD PARK

Justin Piccirillo

ARCADIA
PUBLISHING

Published by Arcadia Publishing
Charleston, South Carolina

Printed in the United States of America

Library of Congress Control Number: 2020943803

For all general information, please contact Arcadia Publishing:
Telephone 843-853-2070
Fax 843-853-0044
E-mail sales@arcadiapublishing.com
For customer service and orders:
Toll-Free 1-888-313-2665

Visit us on the Internet at www.arcadiapublishing.com

*To the citizens of Meriden, as this park continues to be a part
of our identity and a source of pride in our community.*

CONTENTS

ACKNOWLEDGMENTS

Thank you to the many wonderful people of Meriden who have inspired, influenced, and contributed to this book in some way. Brian Cofrancesco, your friendship is unparalleled and your knowledge and expertise know no boundaries. I wish to extend my sincerest thanks for all of your hard work toward this project. Thanks also to: Allen and Neda Weathers, words cannot begin to explain how indebted I am to you both; Sheri Deluca, for entrusting me with the research efforts of your father, the late Meriden historian Dan W. Deluca; the family of James J. Barry, including his children, the late Jim Barry Jr. and Patricia Barry Prestipino, and his granddaughter Kyle Barry; and former Meriden Parks and Recreation director Mark Zebora.

This book would not have been possible without the kind cooperation and assistance of Sherwin Borsuk and the entire staff at the Meriden Historical Society.

A very special thank-you to the Meriden City Hall staff: Kevin Scarpati, Robert Kosienski Jr., Tim Coon, Denise Grandy, and Krista Martino.

I am very grateful for support from Chris Bourdon and Kathy Matula of the Meriden Parks and Recreation Department.

Little could have been achieved without the tireless work of Becky Starr, Jan Franco, Laura Pudvah, and the staff at the Meriden Public Library.

Thank you for making this happen, Liz White Notarangelo, Erik Allison, and Ritchie Rathsack of the Meriden *Record-Journal*.

Heartfelt appreciation to Dean Santor, Bruce Rovinsky, Marion Muskiewicz, Seth Eddy, Molly Savard, Lynne Cormier Vigue, Eric Meindl, Dave De Lancey, Peter Wnek, Michael Giacco, John Ramsey, Rick Walsh, Vinnie Mule, Hector Cardona Sr., Lesley Solkoske, Maureen Cahill Altobello, Kevin Quinlan, Darrell Lucas, Rick Messina, Ellen Messina, the Lamphier family, Craig Schroeder, Robbie DeRosa, Leigh Trostel, Stephen Metcalfe, Carol Baum, Sandi Jacques, Bruce Burchsted and Mike Glynn at Prentis Printing, and Marie Secondo of the Barnes Museum of Southington.

Thank you to my editor Caroline Anderson at Arcadia Publishing.

Thank you to my wonderful parents, Duane and Diana Piccirillo, for instilling in me a love for our city, and lastly, thank you to my dearest wife, Jennifer, and sons Clayton, Adam, and Anders. Your patience and understanding throughout the making of this book did not go unnoticed.

Unless otherwise noted, all images are from the personal collection of the author.

INTRODUCTION

The story of Hubbard Park begins nearly three centuries ago. Sometime around 1750, Daniel Johnson arrived in what we know today as Meriden. He acquired a large tract of land south of the Hanging Hills and within "the Notch" from John Yale, one of the first planters in Wallingford. Johnson's farmland was expansive and encompassed part of the West Mountains, including all of the area known today as West Peak. Traveling in a canvas-roofed vehicle, the Johnson family was perceived as elegant and of a high social standing. Despite the perceptions, their mountainous forest was considered fairly worthless to most as it contained vast amounts of hemlock, an objectionable timber.

For the next 100 years, the land and its ample supply of brooks, lakes, and ponds were used for farming, hunting, and fishing. During the winters, the water holes yielded great supplies of ice for local residents. In the early 19th century, great numbers of prospective miners congregated on an isolated hill named Mining Hill after word spread that gold and other precious ores could be found beneath it. Only traces of iron pyrite were uncovered, and the damming of the waters years later—creating Merimere Reservoir and Miner's Island, which was later shortened to Mine Island—limited access to further mining. Legend suggests that this "boom" may have been the result of deception in an attempt to raise property values.

Meriden saw great change in the mid-19th century. A surge in population and industry transformed the town from an agricultural hamlet to a seasoned, manufacturing city. In 1869, just two years after Meriden was incorporated, wealthy industrialist Walter Hubbard acquired his first parcel of land within the Hanging Hills from the Johnson family. As one of the most distinctive features of the Connecticut landscape, the Hanging Hills are a nearly continuous line of traprock ridges that rise 1,000 feet above sea level to create a spectacle of elevations and valleys. It has been said that Hubbard was so taken by the landscape and primitive beauty of the newly built Merimere Reservoir that he decided early on to build an area of respite on the land.

After his initial purchase, Hubbard continued to acquire and preserve land in the surrounding area, often anonymously. One by one, he purchased segmented tracts of East and West Peaks and South Mountain, which, unbeknownst to most, he hoped to assemble into a city recreation area. However, at the time, the City of Meriden Charter did now allow for such parks. In fact, prior to 1881, Meriden had no land provided for recreation. An amendment to the city charter was approved in January 1882 that provided for the establishment of what is now City Park. This was precisely what Hubbard needed to begin to build a park of his own.

Hubbard initiated construction in the late 1890s, combining several hundred acres of his land with acreage already owned by the city. He actively supervised and financed the work of architects and builders who realized his plans for naturalistic roads, pathways, waterways, structures, and buildings. In 1897, land was cleared to begin building roads and paths and to develop Mirror Lake.

Mirror Lake was, and still is, Hubbard Park's centerpiece. Before receiving its permanent name, residents referred to this natural body of water as the "Old Res," short for Old Reservoir. It was the park's primary place for water recreation, featuring a bathing beach, boats, and fishing.

During the winter months, it was a popular spot for ice fishing, skating, and ice harvesting. As the lake grew in popularity, it was given the name Mirror Lake for the near-perfect reflection of the surrounding Hanging Hills cast in its waters.

As work progressed on the park's roads and Mirror Lake, a key donation of land enabled Hubbard and his team to construct a main entrance from West Main Street. In mid-1897, manufacturer and Meriden's first mayor Charles Parker donated land originally owned by the Johnson family to the city, which in turn designated it to Hubbard for his park. Most recently used by Parker's relative Julius Parker for the production of locks and hardware, the land came with an old stone foundry that was ultimately cleared from the property. Construction of the sweeping Park Way entrance—with an adjoining waterfall, bridge, and fountain—then began.

The lower portions of the park were predominately grassy with very few trees, but plenty of flowers and shrubs. There were some older trees around the lake, but most of East and West Peaks were barren rock—the land had been deforested to supply wood for cooking fires, heating homes, and to power the city's many industries. When Hubbard's work crews built carriageways and cleared paths for scenery viewing, they were not impeded by tall pines and oak trees; it was not until well into the 20th century that Hubbard Park was reforested. Most of the first advancements in the park were done beginning in 1898 and were concentrated in the 118-acre southern section, including the 68-acre area commonly known as "the park" by visitors today.

The name Hubbard Park was first used in a *Meriden Record* article on July 13, 1897, and was fully adopted by the city on March 7, 1898.

As Hubbard Park took shape, Walter Hubbard took a long, hard look into the future of his park. He decided that he needed a second opinion on his design and sought the advice of Frederick Law Olmsted. Considered the "Father of the American Park Movement," Olmsted was quick to connect Hubbard with his son John Charles; nearing the age of 80, the elder Olmsted was too old to travel to the park. Hubbard agreed to pay a $100 fee and traveling expenses, and on April 23, 1898, John Charles Olmsted made the trek from Boston to Meriden.

Olmsted's visit resulted in seven letters to Hubbard outlining his observations on the developing park and his suggestions for its design. It was Olmsted's second letter, dated May 25, 1898, which proved most critical for Hubbard, as soon thereafter the park's design underwent a transformation. The park's architecture changed from the classical aesthetic of Hubbard's Grecian Temple—the only structure built prior to Olmsted's visit—to the more rustic style of the Fairview Observatory, designed just months after Olmsted's letter.

While some of Olmsted's suggestions were incorporated, Hubbard Park still boasted many of Hubbard's original touches. One of these original designs was the beehive motif used sporadically throughout the park. Hubbard may have been inspired by the ancient Roman symbol representing the wisest uses of nature, seen during his European travels. He incorporated the motif in the construction of large fountains just outside the park's entrance, along with several other beehive-shaped springs throughout the park.

Aside from his impact on construction, Hubbard is also credited with naming points of natural interest within the park. These include Boulder Bluff, White Rock, Fairview Point, Beehive Spring, Maid of the Mist Fountain, Hanging Gardens, Notch Road, Garden of the Rocks, and Eagle Crag.

As the park continued to grow and take shape at the start of the 20th century, Hubbard prepared to construct the crown jewel: a 32-foot stone observatory to be known as Castle Craig Tower. Inspired by a bridge he had seen while traveling in Scotland, Hubbard employed David Stuart Douglass, a young designer at the Bradley & Hubbard Manufacturing Company, to draw up plans for a castle that would sit atop the park's highest peak.

On October 29, 1900, Walter Hubbard hosted a special celebration atop East Peak to commemorate the completed tower. With many people in attendance, and in the shadow of the landmark tower, he formally donated the park and tower to the people of Meriden. Hubbard Park was his legacy, a gift presented to the city.

Hubbard Park became Meriden's gathering place. In the early years of the new century, new social and cultural shifts paved the way for the park's early popularity. Physicians began recommending

physical activity, spectator sports became popular, and streetcars enabled citizens to escape the urban environment for the clean air and beautiful surroundings that Hubbard Park offered. People traveled from all over the city, state, and region to visit this special park as trolleys ushered in crowds by the masses throughout the day; a typical summer weekend could draw 5,000 to 10,000 visitors to the park.

With his donation of the park, Walter Hubbard gave the land and structures outright to the City of Meriden with just one stipulation: that everything within the park always be free of charge for the people of Meriden and that no for-profit concessions be present in the park. This stipulation has been greatly debated for more than a century and was tested within one year of the park's dedication. During the summer of 1901, soon after construction of the trolley waiting station was complete and the streetcar lines to the park were established, crowds of people flocked to the park. One day that summer, a few kids rode a streetcar to Hubbard Park with the hopes of making a little extra money selling peanuts at the park entrance. As people exited the streetcar, the children tried selling their nuts. Some visitors found the children unruly, and when Hubbard learned of their antics, he swiftly moved the children away from the park.

Henry T. King, Hubbard's counsel and later park commissioner and mayor, approved free band concerts within the park beginning in 1907; frequent performances by the Meriden City Band attracted audiences of 5,000 people from miles around. Despite his advanced age, Hubbard invested much of his personal time, energy, and finances into overseeing the park, catering to its recreation potential.

The park continued to flourish, even after Hubbard's death in 1911 at the age of 82. However, without Hubbard's fortitude and attention to detail, the next few decades were unsteady. Notch Road saw the loss of its child-friendly squirrel cage, tollbooth, and large boardinghouse and barn. The Hubbard Park Boathouse closed its doors sometime before 1920, and automobiles were prohibited in the park until 1927. Swimming at Mirror Lake was halted and did not resume until 1929, when Mayor Wales Lines deBussy proclaimed it a Meriden municipal beach. Castle Craig Tower fell into disrepair and required reinforcement, but the roadways were overgrown and passable at best, so revitalization was questioned. Despite the changes and instability, the park was still heavily visited.

The Great Depression of the 1930s hit Meriden hard, but the period brought welcomed improvements to the park. In 1930, for example, under park superintendent Pasquale Yaia, the Meriden YMCA hosted its first Easter Sunday sunrise observance at Castle Craig Tower, a local tradition that continues today. The Works Progress Administration reconstructed the drive to West Peak and restructured several waterways around the park, creating new opportunities for public fishing for both adults and children.

In 1932, early in the Depression, the city hired 25-year-old James J. Barry as a park laborer and assistant to superintendent Donald Robison. Barry had a deep interest in horticulture, which was evident in his initial layout of flower beds along the park's entrance. It had been a number of years since the park had seen such creative improvements, and Barry's additional floral arrangements each year made him an asset to the parks and to the city. In 1944, following the sudden death of Donald Robison, Barry was promoted to park superintendent.

Barry's tenure was a time of both beauty and frustration. Just as Meriden was pronounced the Nation's Ideal War Community in 1944, the park's landmark Civil War cannon, known locally simply as the "mortar," was donated to a national scrap drive, much to the dismay of residents. A few years later, in the fall of 1948, Barry approved the purchase of 1,000 daffodils to beautify the wooded areas just west of Mirror Lake.

During this period, concert performances at the Grecian Temple became popular, with audiences congregating on the inclining field beside the temple. As crowds grew, it became clear that a suitable performance space was needed. Barry recognized that the incline of the land beside the temple provided a natural amphitheater of sorts, and in 1953, a proposal was made to construct a band shell stage in that spot. Construction finished in 1956, and the band shell was later named in Barry's honor.

In the 1960s, rumors began to spread that 46 acres of Hubbard Park would be taken by the State of Connecticut through eminent domain for the construction of a highway. As the rumors became a reality, and despite local disapproval and several city appeals, the state moved forward with construction of Connecticut Route 66, later Interstate 691, a connector between Interstates 84 and 91. Ultimately, this highway crossed right through the park and divided it in two. Highway construction also negatively affected three other city parks.

In an effort to halt construction, prominent Meriden resident Cornelius Danaher wrote an impassioned article in the *Meriden Record*, "Rape of Hubbard Park: A Sacred Trust Betrayed." Danaher publicly scolded the state for its plans to seize land from four city parks to construct Route 66. The front-page commentary had very little effect, and the Connecticut Supreme Court ultimately ruled in favor of the state and the highway project.

Through dismay and hardship, Walter Hubbard's vision for a suitable recreational facility is what led to the park's popularity and prosperity. It continued to attract people from across the region for hiking, swimming, tennis, and more. The park became so popular with out-of-town visitors in the late 1950s and early 1960s that stickers and swim tags were issued to city residents to ensure they could enjoy the park on weekends despite the high number of outside visitors.

Barry's daffodils became the hallmark of Hubbard Park during these decades. In 1953, he designated the first yearly bloom of Hubbard Park's daffodils as the official first sign of spring. Years later in 1970, Mayor Donald T. Dorsey established the last Saturday and Sunday in April as Daffodil Weekend. Eight years later, a small group of volunteers with a donated budget of $635 established a four-hour celebratory picnic acknowledging the yearly bloom. This quaint celebration was considered the first Meriden Daffodil Festival.

As the city changed, so did the park. A zoo established by the Soroptimist Club of Meriden came and went, as did Camp Hubbard, a city-run camp for children.

One of the volunteers who helped establish the Daffodil Festival was Mark Zebora, a future park employee whose keen foresight and intuition brought a new direction for the park. With his elevation to director of parks and recreation in 1986, he saw opportunities to increase the park's reach and use. He worked to enhance Hubbard's initial waterways, promote the Meriden Daffodil Festival to reach greater numbers, and implement celebrations like Christmas in the Park and the Festival of Silver Lights. Under Zebora's tenure, Hubbard Park was listed in the National Register of Historic Places in 1997 as a significant example of architecture and engineering.

More than 51 parcels of land, including 150 acres formerly known as the Hubbard State Park, comprise today's 1,800-acre Hubbard Park. Hubbard's ingenuity and the work of his successors have preserved and accentuated the natural splendor of this special place, now one of the largest municipal parks in New England.

Bountiful beauty, history, and legacy remain the hallmarks of Hubbard Park. The historic structures, Hanging Hills, and remnants of the past are paired with the additions of a swimming pool, band shell, and Festival of Silver Lights to serve as a reminder of the generous gift and legacy of Walter Hubbard.

One

WALTER HUBBARD

Walter Hubbard, Meriden's greatest single benefactor, was born in Middletown, Connecticut, on September 23, 1828. Like many youth of his day, he grew up on a farm and was educated in the township schools. At the age of 18, he secured a position as a clerk in a general store where, by his thrift, energy, and strict attention to his employer's interests, he accumulated enough capital to embark into business for himself. This he did, and in 1851, Hubbard opened a small dry goods and clothing store in Meriden, which he ran until 1860.

Hubbard was married in 1852 to Abby Ann Bradley, the daughter of Levi Bradley, a prominent farmer in neighboring Cheshire. She died within a few months, and Hubbard never remarried. In 1854, in company with his brother-in-law Nathaniel L. Bradley, Hubbard founded the Bradley & Hubbard Manufacturing Company. The firm became one of the largest manufacturers of lamps in the world.

Politics never had any attraction for Hubbard. Unlike other leading industrialists of the time like Charles Parker, Hubbard never held high public office. He did however serve as a councilman on the first city council in 1867 and was active in assisting Mayor Parker in organizing Meriden's first permanent, paid police department. Hubbard never sought reelection.

As early as 1869, Hubbard began acquiring land in West Meriden adjacent to the Hanging Hills. Over the next three decades, he continued to buy land at a frantic rate, pushing the boundaries of his property well beyond 1,000 acres. In April 1897, Hubbard set out to develop his land into a park. Roads, masonry, and fountains began to appear at the feet of the traprock hills. Residents streamed to the incomplete park, by then aptly named Hubbard Park, by the thousands for picnics, boat rowing, and skating on Mirror Lake, the park's centerpiece. On October 29, 1900, upon completion of the Castle Craig Tower, Hubbard Park was dedicated and gifted to the people of Meriden.

Walter Hubbard continued to be actively involved in the park's development until his death in 1911.

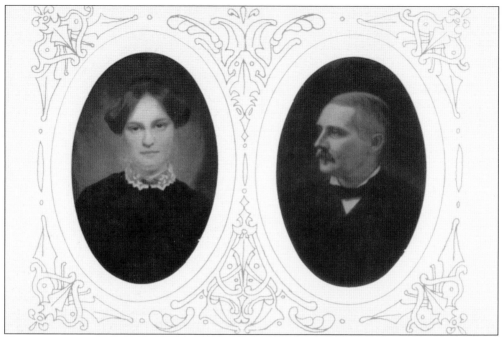

HUBBARD AND BRADLEY MARRIAGE. Hubbard was a successful businessman by the time he turned 24 in 1852. That same year, he married Abby Ann Bradley, the daughter of a prominent farmer, Levi Bradley, in neighboring Cheshire, Connecticut. Abby died less than six months after their wedding, just one day before her 20th birthday. Hubbard never remarried. They are buried together in the Hubbard Memorial Chapel in Meriden.

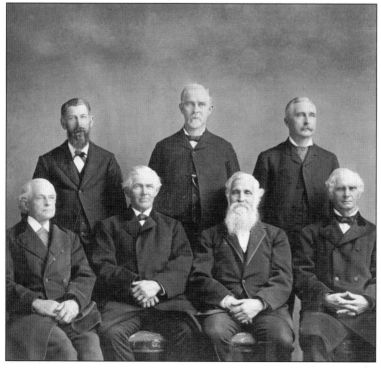

HUBBARD FAMILY PHOTOGRAPH. This mid- to late-19th-century photograph shows the men of the Hubbard family. From left to right are (seated) Ebenezer Prout Hubbard, Herbert R. Hubbard, Robert P. Rand (husband of Elizabeth R. Hubbard), and Joshua Hubbard; (standing) Jeremiah Warren Hubbard, George W. Hubbard, and Walter Hubbard. (Courtesy of Allen Weathers.)

Nathaniel Bradley. In 1854, Walter Hubbard formed a partnership with his brother-in-law Nathaniel Bradley (pictured) to manufacture clocks and metal wares and later, oil-burning lamps. Incorporated in 1875 as the Bradley & Hubbard Manufacturing Company, the firm operated from a small frame factory building on Hanover Street in Meriden before expanding to cover a six-acre complex of four-story brick buildings and brass and iron foundries. (Courtesy of Allen Weathers.)

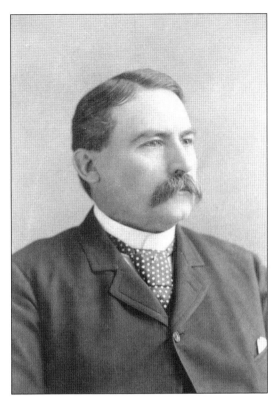

AS EASY To LIGHT AS GAS · SATISFACTORY IN EVERY PARTICULAR

BEAUTY · STYLE ·

B & H LAMPS

Superiority of Construction and Finish commend Our Products to all Purchasers. They are sold by Leading Dealers everywhere. *Little Book* of information *sent Free.* Fine Art Metal Goods, Gas and Electric Fixtures, &c.
BRADLEY & HUBBARD MFG. CO.
MERIDEN, CONN.
NEW YORK. BOSTON. CHICAGO. PHILADELPHIA.

Bradley & Hubbard Manufacturing Company. By the late 19th century, the Bradley & Hubbard Manufacturing Company was synonymous with high quality and artistic merit. The company continued in operation until 1940, when it was purchased by the Charles Parker Company, also of Meriden. The B&H brand of fine lamps and metal ware remain some of the most sought-after collectible housewares in the world today.

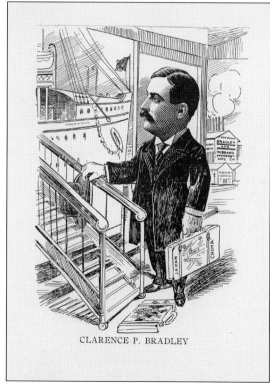

CLARENCE P. BRADLEY

WINTHROP HOTEL. In 1883, Walter Hubbard built the Winthrop Hotel in Meriden. Just before its completion, the hotel's name was still undecided, and Hubbard grew desperate. The first proposed name, the Hubbard, was quickly abandoned, as was Hotel de Britannic. After ruling out several options, the name Winthrop was selected, after Connecticut's colonial governor John Winthrop Jr. It was destroyed by a fire in the 1950s.

LEGENDARY TRIP. On July 30, 1883, Walter Hubbard left Meriden with his nephew Clarence Bradley (pictured in caricature) on the 12:46 p.m. express train for a trip around the world. At the depot, a number of prominent gentlemen gathered to wish them a pleasant trip and safe return. Their itinerary began with a cross-country train ride to San Francisco before sailing to China. They spent the next year circumnavigating the globe.

BESSIE HUBBARD PIERCE.
Bessie Hubbard Pierce
(left) was the niece and
adopted daughter of
Walter Hubbard. After
his brother Ebenezer's
death, Hubbard was
entrusted with his
niece's guardianship,
and the two were often
seen in Hubbard Park
together. Pierce was a
prominent member of
Meriden society, active
in several church affairs,
and was deeply invested
in the Girl Scouts
program. (Courtesy of
Brian Cofrancesco.)

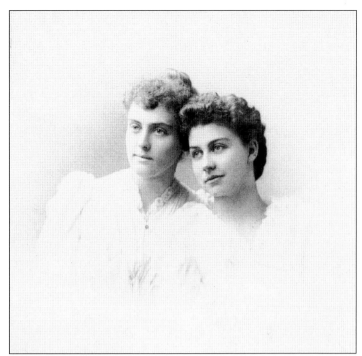

HENRY T. KING. Walter Hubbard's
attorney and confidante Henry T.
King held practically every office in
city government during his 64-year
political career. During his tenure as
park commissioner, King initiated free
band concerts in Hubbard Park. In
later years as Meriden's mayor, King
was responsible for adding Meriden's
famed traffic tower downtown and
helped to define the city's traffic rules.

MAYOR AMOS IVES. On February 21, 1899, a comprehensive amendment concerning public parks was made to the city charter and resulted in the appointment of a board of park commissioners. Under this amendment, the board provided management, care, and control of the city's parks. Led by Mayor Amos Ives (pictured), the board gave Walter Hubbard a long-term appointment.

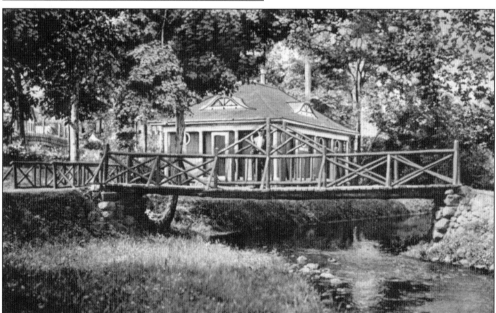

BROOKSIDE PARK. In 1901, Walter Hubbard and foreman Patrick Quigley set out to create another recreational area, Brookside Park. Although Hubbard provided the financial backing, Quigley is credited with the surveying and grading of the land, adding floral decorations, and furnishing the children's swimming pools. In fact, Quigley's flower beds received such admiration that the individual Meriden firehouses began adding to it, greatly improving the park's beauty.

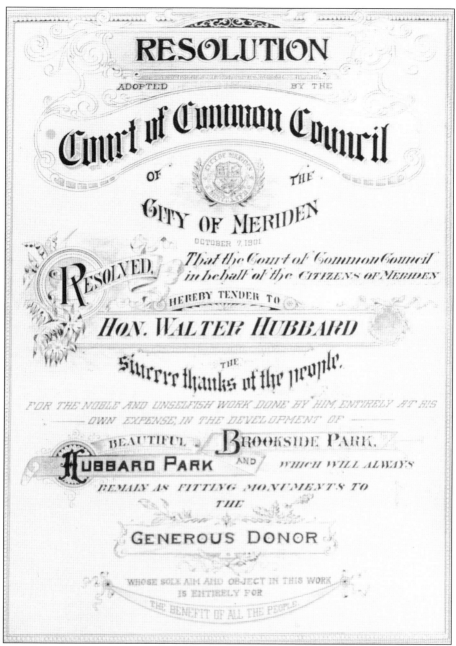

RESOLUTION

ADOPTED BY THE

Court of Common Council

OF THE

CITY OF MERIDEN

OCTOBER 7, 1901

RESOLVED, *That the Court of Common Council in behalf of the CITIZENS OF MERIDEN*

HEREBY TENDER TO

HON. WALTER HUBBARD

the Sincere thanks of the people.

FOR THE NOBLE AND UNSELFISH WORK DONE BY HIM, ENTIRELY AT HIS OWN EXPENSE, IN THE DEVELOPMENT OF

BEAUTIFUL **B**ROOKSIDE PARK.

HUBBARD PARK AND WHICH WILL ALWAYS

REMAIN AS FITTING MONUMENTS TO THE

GENEROUS DONOR

WHOSE SOLE AIM AND OBJECT IN THIS WORK IS ENTIRELY FOR THE BENEFIT OF ALL THE PEOPLE

WALTER HUBBARD RESOLUTION. This detailed, hand-inked scroll was presented to Walter Hubbard on October 7, 1901, for his generous gifts of Hubbard and Brookside Parks to the citizens of Meriden. The document paid tribute to the benefactor "for the noble and unselfish work done by him entirely at his own expense in the development of beautiful Hubbard Park and Brookside Park, which will always remain as fitting monuments to the Generous Donor whose sole aim and object in this work is entirely for the benefit of all the people." After Hubbard's death in 1911, the scroll was granted back to the city. Decades later, it was turned over to James J. Barry, superintendent of parks, who planned to have it encased in plastic and placed in Hubbard Park, but this plan was never realized. The scroll was returned to the city's archives. (Courtesy of the *Record-Journal*.)

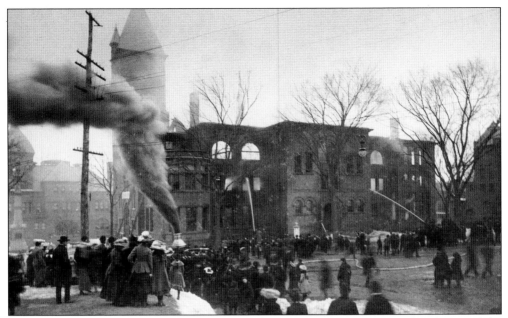

FUTURE OF THE CITY HALL SITE. After the February 14, 1904, fire (pictured) that destroyed the Meriden City Hall, officials vehemently debated the site's future. A recurring idea was to develop the site as another city park. Walter Hubbard, a respected local voice, opposed this. "Meriden has enough parks," he said. "We should erect a new, modern building without a public hall and put the police into separate headquarters."

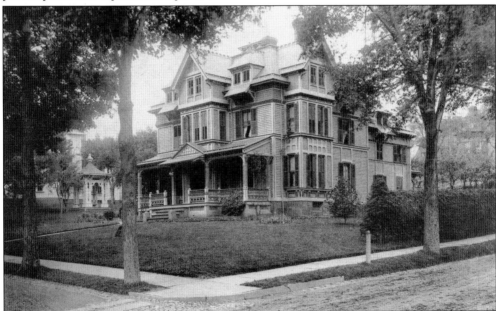

WALTER HUBBARD'S RESIDENCE. Walter Hubbard lived in this handsome mansion on Washington Place. It was built by his brother Jeremiah Warren Hubbard, a Middletown carpenter. Over time, it underwent many renovations. When Hubbard died in 1911, his niece Bessie Hubbard Pierce inherited the house and lived there with her husband, Dr. Elbridge W. Pierce. After their deaths, the home was sold and partitioned into apartments. It caught fire and was destroyed in the 1970s.

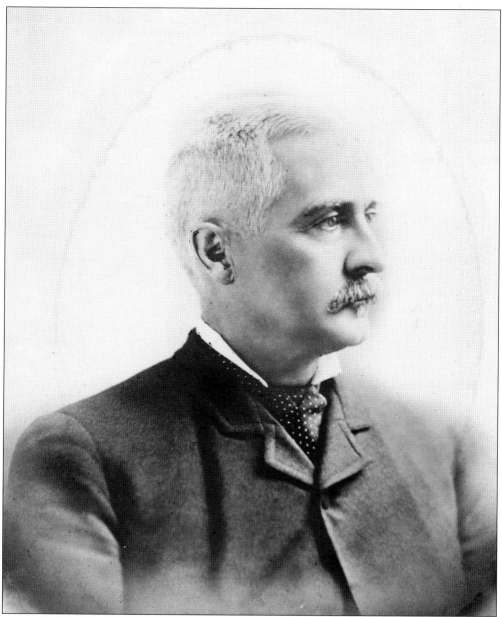

WALTER HUBBARD'S WEALTH. Walter Hubbard's wealth came from his leadership in manufacturing. In 1901, it was estimated that he invested $75,000 on three years of construction at Hubbard Park. When he died in 1911, his estate was still valued at nearly $3 million, more than $65 million today. Hubbard's estate was the largest ever probated in Meriden at that time. His will provided for numerous bequests to family, friends, and organizations. Besides his gift of the 1,200-acre Hubbard Park on Meriden's westernmost border, his will established a $40,000 trust at Wesleyan University, a $50,000 trust for Hubbard Park, a $50,000 trust for the "Worthy Poor of Meriden," and $25,000 in trust for the Curtis Memorial Library. He also left $10,000 in trust for the First Congregational Churches of Meriden and Middletown and $5,000 in trust for the Meriden Boy's Club. He also left outright bequests totaling some $30,000 for a number of local churches and organizations, including the Meriden Fire Department Relief Fund, the YMCA, and the YWCA.

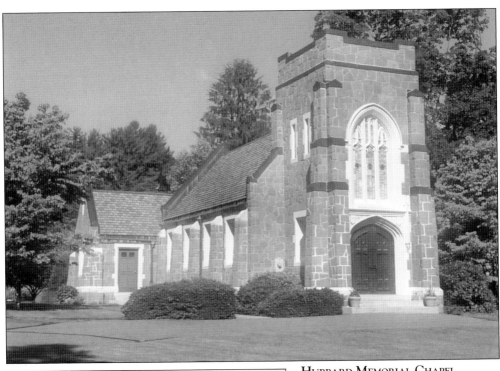

HUBBARD MEMORIAL CHAPEL.
Walter Hubbard died on August 24, 1911, in Burlington, Vermont, one month short of his 83rd birthday. In his will, he bequeathed funds for the construction of the Hubbard Memorial Chapel, a memorial to his wife, Abby, and himself. Located in Meriden's Walnut Grove Cemetery, it is built with traprock quarried from the nearby Hanging Hills. Walter and Abby are interred beneath the altar of the chapel.

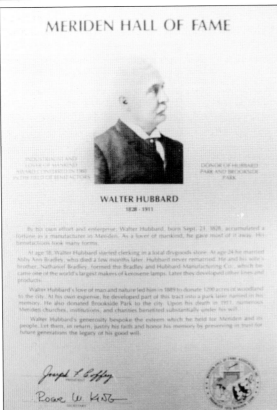

HUBBARD ELECTED INTO THE MERIDEN HALL OF FAME. In 1980, Walter Hubbard was inducted into the Meriden Hall of Fame in the Benefactors category. Organized in 1975, the Meriden Hall of Fame Association was established to honor prominent people of Meriden. Today, a plaque honoring Hubbard is proudly displayed, alongside those of the other hall of fame inductees, in Meriden City Hall.

Two

EARLY DEVELOPMENT

In May 1869, Walter Hubbard acquired his first tract of land in West Meriden. It was a quitclaim for 79.5 acres along the Merimere Reservoir to be purchased by the city and further outrighted to Hubbard. Over the next quarter century, Hubbard continued to purchase the land surrounding the reservoir.

Hubbard's intentions for building a park on his land were not made public until years later. Sometime around 1881 in a conversation with well-known local newspaperman Francis Atwater, Hubbard shared his conception of a local park project. His initial plan in creating a park was simple: to construct an archway over a southern entrance to his property to welcome visitors to his land. Not long after this conversation, Hubbard embarked on an around-the-world trip with his nephew, only to return with a change of plans. His new vision for the park was on a much greater scale—a glorious park spread across more than 1,000 acres of the natural Hanging Hills landscape. This new vision developed into the Hubbard Park of today.

Hubbard was discreet with most of his plans for the park, and he remained steadfast as those plans were realized and Hubbard Park took shape. Even as the weather turned cold each year and ice began to build up around the park's new fountains, Hubbard continued. In a November 1897 *Meriden Daily Journal* article, Hubbard was asked how much longer the work would continue, to which he responded: "We will keep at it until everything is frozen tight and our money is all gone."

As development and construction continued, people began visiting the park. Despite it being incomplete, Hubbard did not seem to mind the interest from local residents. Each day, he would reach the park around noon to inspect the day's progress and to watch visitors. This period of early development forged Hubbard's life. Nearing 70 years old in 1898, he would often blush when people praised his work. One newspaper reported that he would reply that the park would be "as handsome as nature, money and good taste could make it."

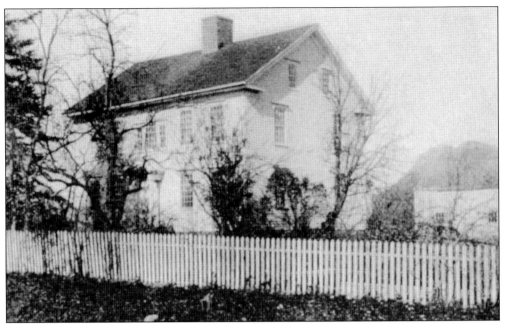

JOHNSON HOMESTEAD. This is the original Johnson homestead, built around 1785. During the mid-18th century, the drive on which this home stands today, Johnson Avenue, was Meriden's main east-west route. Years later, this road became the key stagecoach thoroughfare to Waterbury. Walter Hubbard acquired his first tract of land from the Johnson family in 1869, an area surrounding the Merimere Reservoir.

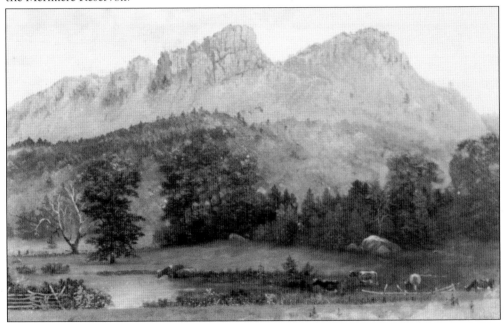

THE HANGING HILLS OF MERIDEN. This view of the Hanging Hills, from a painting by Nelson Augustus Moore, was featured in an article about Hubbard Park in the February 1899 issue of *Connecticut Magazine*. This view from the west clearly shows the notch of West Peak, which was also known as the "Valley of the Shadow of Death." Rolling hills surround the local farmland.

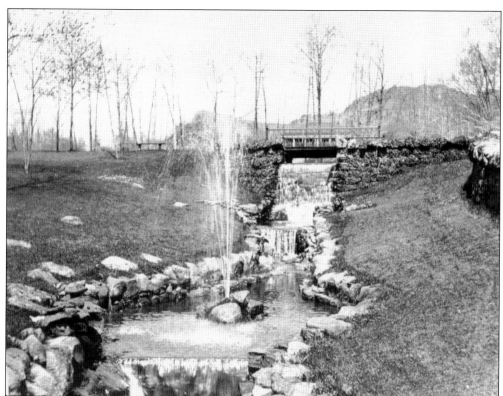

CROW HOLLOW. Crow Hollow, a piece of land that became the park's entrance, was named by William Botsford in 1830. He named the location, near Julius Parker's shops two miles west of the city, for the crows that would congregate along the brook. Crow Hollow Brook is still fed by water exiting Hubbard Park and once provided water for a string of factories along today's West Main Street. Julius Parker relocated around the 1880s and sold his Crow Hollow trimmings and castings outfit to his relative Charles Parker.

CHARLES PARKER. Charles Parker was elected Meriden's first mayor in 1867. His business, the Charles Parker Company, was a leading manufacturer of metalware, tools, lamps, and piano stools. He is credited with creating the Parker shotgun. In June 1897, former mayor Parker donated to the city eight acres where his West Meriden foundry once stood. This land later became the Park Way entrance to Hubbard Park.

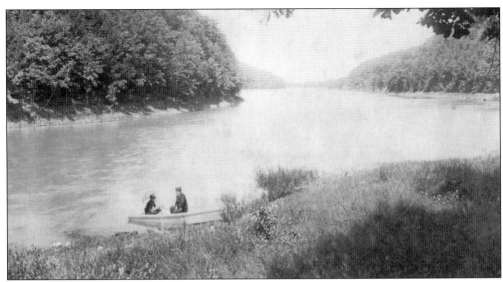

MERIMERE RESERVOIR. With a growing population in the late 1860s, Meriden residents hastily disputed where to build the city's first reservoir. Although many supported building what is known today as Merimere Reservoir, there was growing concern that it would not be a reliable water source for the eastern part of the city. Black Pond on East Main Street, on the border of Middlefield, was also nominated, but Merimere was ultimately selected. Here, a couple enjoys a boat ride on Merimere Reservoir just a few decades after its construction.

OFFICIALLY NAMED HUBBARD PARK. A nature lover all his life, Walter Hubbard often drove his carriage along the shores of Merimere Reservoir, looking up at the majestic beauty of the Hanging Hills. It was in the early 1880s, as he continued to acquire land, that Hubbard devised a plan for building a park. Hubbard is pictured here riding along Cliff Drive, the pathway known today as

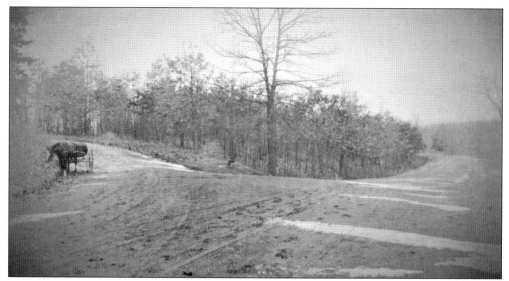

EAST AND WEST PEAKS JUNCTION. The road that follows the Merimere Reservoir and travels up to East and West Peaks was not always an easy route to travel. In the mid-19th century, it was the primary route to West Peak developments, but it was an underdeveloped, dirt path. This late-19th-century photograph of the fork to East Peak (left) and West Peak (right) captures the worn path with carriage wheel tracks, horse hoof prints, and ice patches. (Courtesy of Allen Weathers.)

Fairview Drive. The name Hubbard Park was officially established on March 7, 1898, by an act presented by Alderman Henry T. King. This was confirmed on January 9, 1899, by the Connecticut General Assembly after the state formalized the city's ownership of the park. (Courtesy of the Meriden Historical Society.)

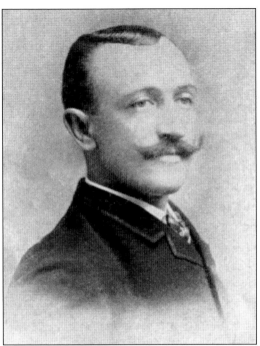

W.S. Clark. W.S. Clark, the surveyor of Hubbard Park, was born in Middletown, Connecticut, in November 1857. After an apprenticeship with the city's engineer, Clark went on to work in masonry construction for a number of local railroads. In the fall of 1887, he came to Meriden and was promoted to city engineer the following January. Clark is credited with laying out the Hubbard Park entrance.

Shady Brook. Shady Brook, one of the earliest sections of the park, is a wooded area along the southwest perimeter with a brook and trail of the same name. The Shady Brook path begins between two stone pillars opposite Eaton Avenue and adjacent to the original Southington trolley stop shelter. It runs alongside the brook and toward Mirror Lake. In 1933, permission was granted to establish and maintain a wildflower sanctuary along this pathway.

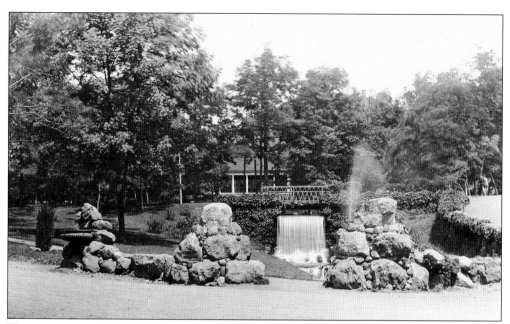

Hubbard Park Entrance. After his June 1897 survey of Hubbard Park, city engineer W.S. Clark recommended that a park entrance and road be constructed from the old Parker iron foundry site alongside Park Way. Today, this entrance road, running beside one of the park's iconic waterfalls, is known as Hubbard Park Way. The entrance's landscaping was designed by Walter Hubbard's early foremen, Walter E. Miller and Patrick Quigley.

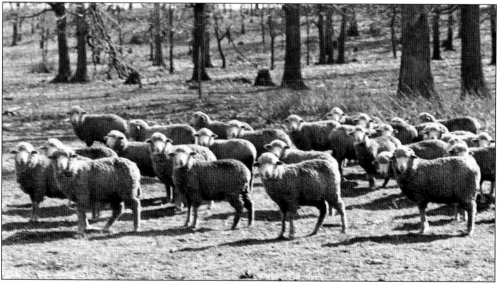

Grazing Sheep. Lawn care was of great importance to Hubbard. He often used a flock of sheep to manicure his land, allowing them to wander freely throughout the park. Imported pheasants were also used, but both were gone by the early 20th century. Evidence suggests that the sheep may have been kept behind the Merimere caretaker George Heil's home, opposite the reservoir, and the fowl in a barn on Notch Road.

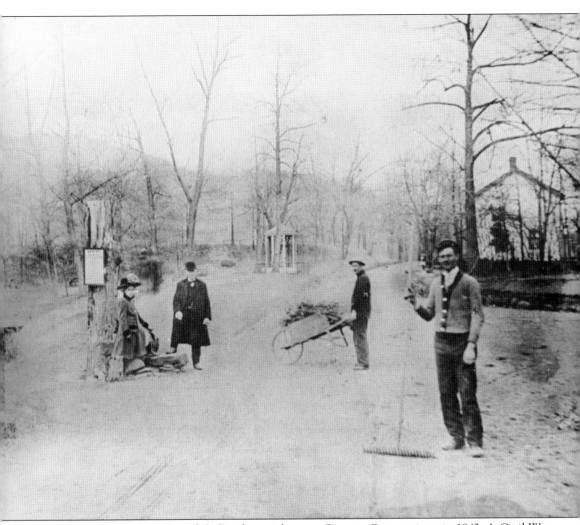

PATRICK J. QUIGLEY. Patrick J. Quigley was born in Orange, Connecticut, in 1842. A Civil War veteran, he moved to Meriden and worked as a foreman at the Wilcox Silver Plate Company. He later worked as a general contractor in the city and became acquainted with Walter Hubbard, who hired him in 1897 to supervise the early construction and development of roads in what would later be Hubbard Park. In this c. 1898 photograph, Hubbard's niece and adopted daughter Bessie Hubbard are at left alongside foreman Patrick Quigley and two park workers at right. They are close to the park's southern entrance on Notch Road, what is today the exit from the park. The following year, Quigley became Meriden's first superintendent of parks, a position whose salary was also paid in part by Walter Hubbard. Quigley was superintendent until his retirement in 1913. He died in 1920 in Meriden. (Courtesy of the Meriden Historical Society.)

SNAKE BROUGHT TO BERNSTEIN CLOTHIERS. One morning in July 1897, park workers were engaged in the capture of a venomous red adder. They tried to get it into a cigar box, but it broke the cover. Then, foreman Patrick Quigley emptied his lunch box and a skillful worker managed to get the snake into the box. Once securely covered, it was jokingly taken to Sigmund Bernstein, a Meriden clothier. Although a terrific surprise, the snake was put on temporary display in the storefront.

DEATH IN THE PARK. On Saturday, September 25, 1897, park laborer John W. Ryan fell victim to sunstroke while constructing one of the park's driveways. His death was the first within Hubbard Park. Ryan was described as a heavily built man who rarely complained of heat or sickness. At 42 years of age, he left a wife and nine children. He is buried in St. Patrick's Cemetery in Meriden. (Courtesy of Brian Cofrancesco.)

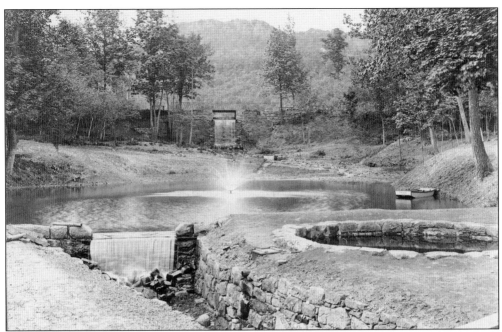

EARLY HUBBARD PARK PANORAMA. This early 1898 photograph shows the newly completed lower park area, later known as the Children's Playground. The view showcases the park's central wading pool, fountain, a secured boat named *Frolic*, and the round trout pool—later the goldfish pond—in the front. The small waterfall in the foreground feeds Crow Hollow, which travels along West Main Street and into the lower pond. The prominent East Peak in the background remained visually untouched until the construction of Castle Craig Tower two years later in 1900.

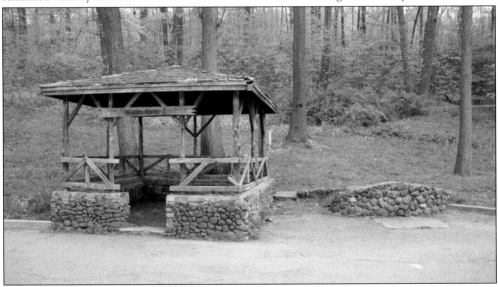

HUBBARD PARK BOATHOUSE. Walter Hubbard directed the construction of a boathouse and wharf to the north of Mirror Lake in the spring of 1898. Boats were lent to park visitors for use on Mirror Lake until the 1920s. The boathouse remains today, though it is now labeled "Spring House," a reference to a natural spring that was once adjacent to the structure. This spring became contaminated and has been permanently sealed.

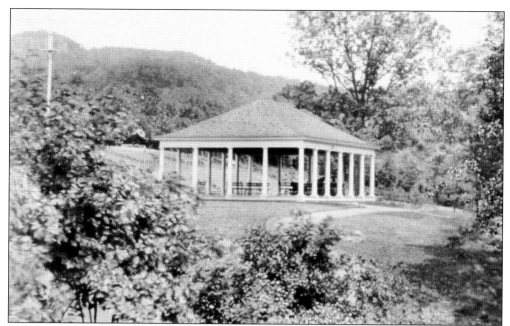

HUBBARD PARK GRECIAN TEMPLE. Hubbard Park's Grecian Temple was the first structure built in the park. Constructed before the spring of 1898, this pavilion predates Hubbard's outreach to Olmsted Brothers and their suggestions for more rustic architecture in the park. It is probable that its Neoclassical design was a product of Hubbard's travels abroad. Originally, it was built as a general-use gathering place, but in 1907, under the direction of Meriden park commissioner Henry T. King, it became a place for band concerts, most notably events with the Meriden City Band. Visible from the original entrance of the park, it has withstood the elements for over a century with minimal repair. There is strong evidence that Bradley & Hubbard draftsman and Castle Craig designer David Stuart Douglass may have designed this building.

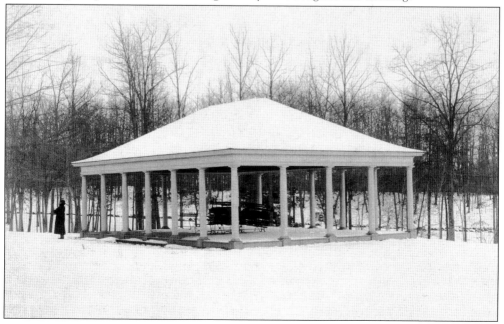

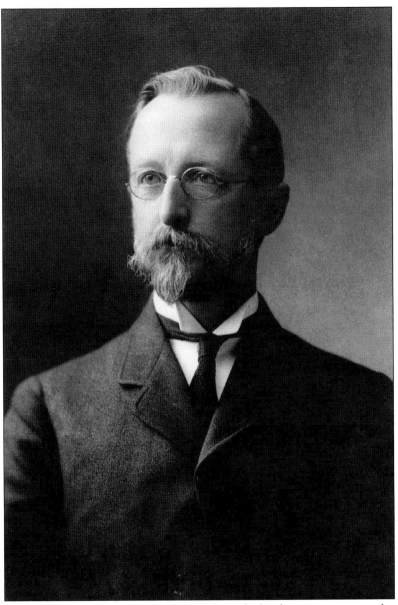

John Charles Olmsted of Olmsted Brothers. As early developments progressed at the park, Walter Hubbard realized that he needed professional advice from a park architect. He invited the renowned landscape architecture firm Olmsted Brothers of Boston to visit the park and to make recommendations for its design and layout. In April 1898, John Charles Olmsted (pictured), nephew and adopted son of famed landscape artist Frederick Law Olmsted, arrived in Meriden to evaluate the park. After visiting the beautiful woodlands, the firm wrote seven letters to Hubbard between 1898 and 1899 making recommendations for improving the park. The firm's recommendations included road and walkway design, landscape treatments around Mirror Lake and Merimere Reservoir, and improvements to the scenic vistas from the mountain peaks. The Olmsted firm also promoted the construction of suitable places within the park to congregate, the use of wrought iron fencing, and keeping nature functional and on-site. Although there is no record of Hubbard's response to these recommendations, he did act upon some of them.

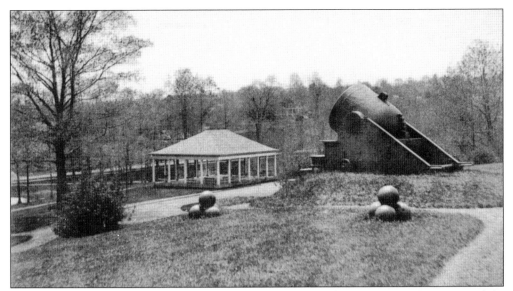

MORTAR COMES TO MERIDEN. The "Petersburg Express" mortar was originally requested for Meriden's Walnut Grove Cemetery by the Merriam Grand Army of the Republic (GAR) post. Locally, there was a growing movement to place the mortar in Hubbard Park instead, to which Hubbard and the GAR post both agreed. On June 4, 1898, the mortar was brought to the park, where it stood guard over the original entrance until 1942.

LIME IN THE TROUT POOL. As construction progressed on the lower park, Walter Hubbard gave orders for the round trout pool to be built up, the stone wall heightened, and a railing erected. When park caretaker Merritt Martindale learned of these plans, he called attention to the potential risks of active masonry work around a pool of live trout. Hubbard disregarded Martindale's warnings, and on June 12, 1898, visitors were surprised to find that 200 trout had been killed or blinded by freshly applied lime used between the stones falling into the water. In response, Hubbard later replaced the trout with goldfish. This c. 1898 photograph shows a gathering of men, women, and children enjoying the remodeled fish pool.

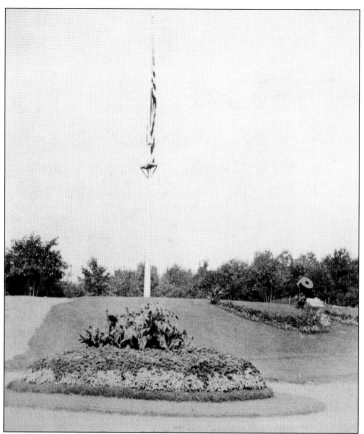

FLAG STAFF. In 1898, Walter Hubbard ordered a flag staff to be erected in the park. It stood close to 75 feet high and was, at the time, the largest flagpole in Meriden. The pole fell during installation but no one was injured. Once the pole was properly secured, the American flag was raised and flown with great pride.

"SOFT STUFF." The spring of 1899 saw wonderful blossoms arranged in the large, round flower bed adjacent to the Grecian Temple. Although the plants were quite pleasing to the eye, a hurried Walter Hubbard was quick to state that little attention should be paid to this "soft stuff," implying that the flower beds would be brilliant for only a brief time and would not satisfy for a full season.

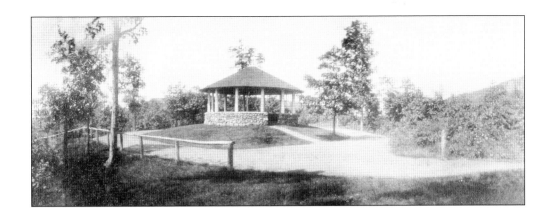

The Fairview Observatory. The Fairview Observatory, the park's second structure, was built on Fairview Point along the route to Castle Craig Tower atop East Peak. Standing at an elevation of 500 feet, it is one of the structures Hubbard incorporated into his early park plans. Erected by Cornelius Kooreman, the Fairview Observatory serves as an observatory and as a shelter to escape rain. It is a round structure with a stone foundation and 12 pillars that support the roof. Seats were originally arranged inside the open-air structure to accommodate visitors. Known today as the Halfway House because of its location halfway up the trail to Castle Craig Tower, it quickly became a popular place to picnic and enjoy the panoramic views. It is said that at one time, with the aid of a telescope, visitors could read the clock on Meriden City Hall. Unfortunately, with the advent of Route 66, the Fairview Observatory became isolated from the lower park.

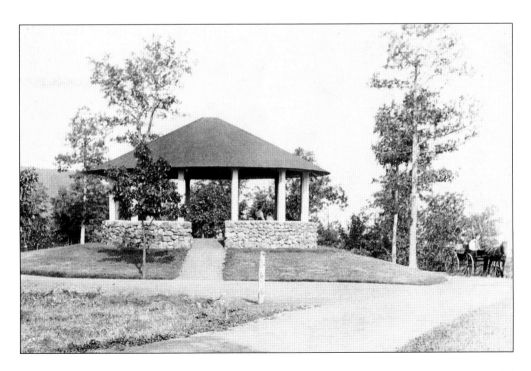

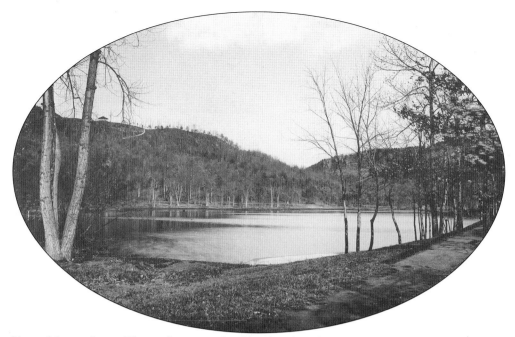

EARLY MIRROR LAKE. This early image of Hubbard Park and Mirror Lake dates to 1899, one year before the construction of Castle Craig Tower. The recently built Fairview Observatory is visible in the distance against the downward slope of East Peak. The famed "Steps to Fairview" can also be seen leading up to Fairview Point. (Courtesy of Allen Weathers.)

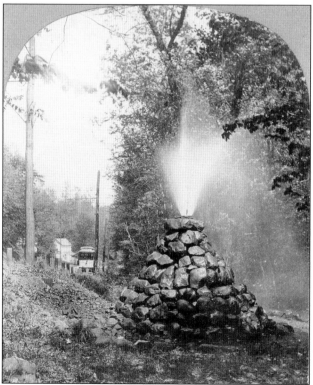

BEEHIVE FOUNTAIN. This beehive-shaped fountain, facing east on West Main Street, was built by Levi Moses, son of Castle Craig Tower foreman William Moses Sr. The fountain stood opposite the base of Hubbard Park Hill and just below Lyra Park, welcoming visitors into the park. Years later, a devastating streetcar accident took place mere feet from this fountain when a trolley with a disengaged brake ran down from Eaton Avenue and was destroyed.

NOTCH ROAD. Notch Road predates Hubbard Park. It was once a heavily traveled road used to reach Mirror Lake for harvesting ice and to get to the reservoir. The house on the right was the caretaker's residence. Records show that James Connorton occupied this building until 1893. Hubbard-employed caretaker Merritt Martindale lived in the house beginning the following year. A makeshift barn stood beside this early structure.

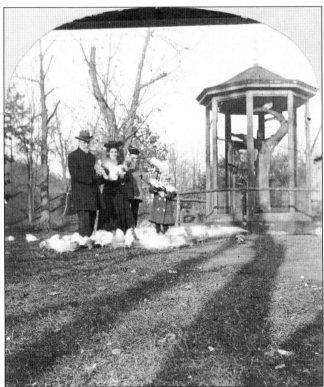

THE HUBBARD PARK DOVECOTE. Seen in this c. 1899 Notch Road image is the Hubbard Park dovecote. Just east of the park's Children's Playground, the structure house Fantail, Pouter, and other varieties of thoroughbred pigeons, and allowed families to watch the birds up close. This enclosure was active in the earliest days of the park but was razed by 1920.

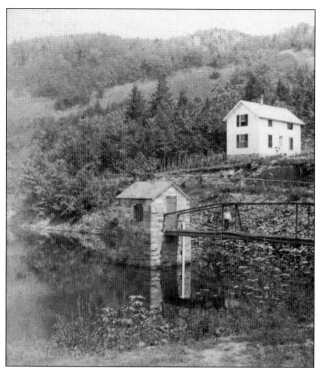

HOME OF THE MERIMERE OVERSEER. This 1900 photograph of Merimere Reservoir prominently shows the water gatehouse as well as the home of caretaker and South Mountain overseer George Heil in the background. Heil lived for only a short time after this photograph was taken, and his successor, Paul Baumgartel, moved into the house soon after. His residency here was brief, as the house was razed only a few years later.

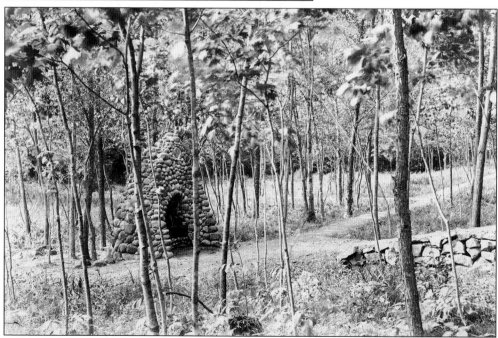

"BEEHIVE" OF YESTERYEAR. This iconic beehive-shaped mound of stones and mortar on the road to Merimere Reservoir was once a spring for park visitors. Later, it was feared that the septic tank from the former caretaker's cottage may have polluted the spring, and it was permanently closed and sealed. For years, the stone monument was deemed nothing more than a park landmark. It was destroyed in the late 1960s for highway construction.

"Stairway to Nowhere." The stone "Stairway to Nowhere" on the eastern side of Hubbard Park Way, near the park's original entrance, was conceived by Walter Hubbard to accommodate carriage owners and passengers as they stepped down from the park's early carriage lot. Years later, three houses were constructed on the site of the carriage lot, but the City of Meriden purchased the properties in the early 1990s and razed the buildings.

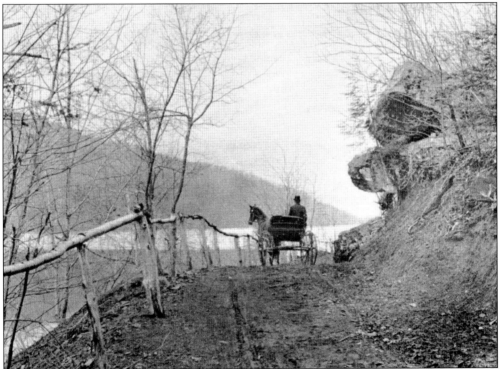

Pulpit Rock. Along the edge of Merimere Reservoir, a hulking mass of traprock named Pulpit Rock protrudes into the road. This c. 1900 image shows the rocks as a horse-drawn carriage continues around the reservoir. The rock formation has been a park attraction for over a century. It is part of the western edge of South Mountain, known as Poor Man's Mountain in Hubbard's time.

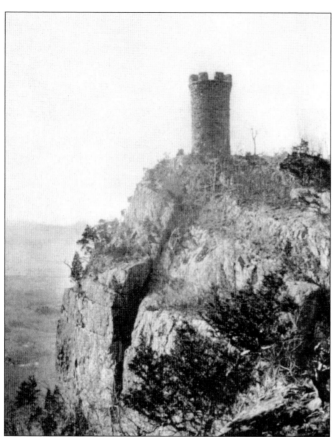

CASTLE CRAIG TOWER, LOOKING WEST. Undoubtedly one of the most familiar landmarks in the central Connecticut area is Castle Craig Tower. Walter Hubbard directed the tower's construction during the spring and summer of 1900. A formal dedication was held on October 29 of that year after it was completed. Both the tower and the park are reminders of the generosity of Walter Hubbard, one of Meriden's greatest philanthropists.

REIMAGINING FAIRVIEW POINT. It is rumored that the cliff Walter Hubbard identified for his Fairview Observatory was one of Daniel Johnson's 18th-century farms. This parcel was part of Johnson's original tract, but the rocky soil and high elevation would have made farming quite a challenge. Hubbard reimagined the land as a scenic overlook and had the path to the cliff developed in 1898 to prepare for construction of the observatory. The path was later named Cliff Drive.

Early Map of Hubbard Park. This is the original Hubbard Park map, probably drawn by Walter Hubbard himself just two weeks after donating the park to the city. It depicts all the drives, ponds, and features of the park from that time. The map was inserted into pocket pamphlets that Hubbard produced for visitors to the park.

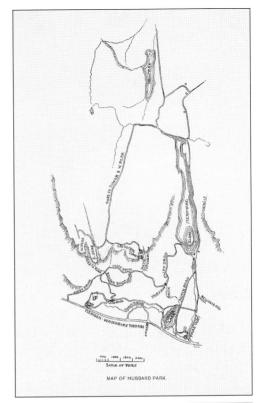

MAP OF HUBBARD PARK.

"Maid of the Mist." Hubbard Park has witnessed the Maid of the Mist on multiple occasions. In colder years, water from the park fountains froze in layers and created massive ice sculptures. In Native American legend, Lelawala was a beautiful maiden who was married off by her father to a king. However, she despised her arrangement and longed to be with her true love. As she went to find him, she was swept underwater and caught before she could drown. Lelawala is known as the original Maid of the Mist.

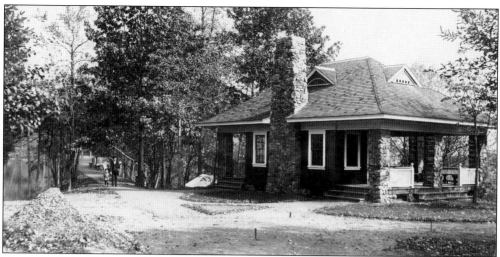

HUBBARD PARK WAITING STATION. Completed in August 1901, the Hubbard Park waiting station was built in response to the thousands of people who visited the newly dedicated park each weekend. Hubbard planned for a structure where women could sit and sew and men could meander while waiting to board the local electric cars. Hubbard also deliberately placed the Children's Playground within walking distance of the station to accommodate families. Toilet rooms for ladies and men were on the ground floor, and a large covered room with ample railings, seats, and scenic views into the park was on the second floor. As the automobile became more popular, the station was no longer needed. Since then, the building has served as a refreshment stand, a skate house, and as the meeting room for Camp Hubbard, a popular summer camp program.

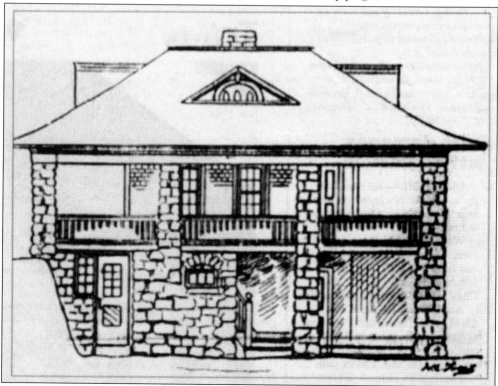

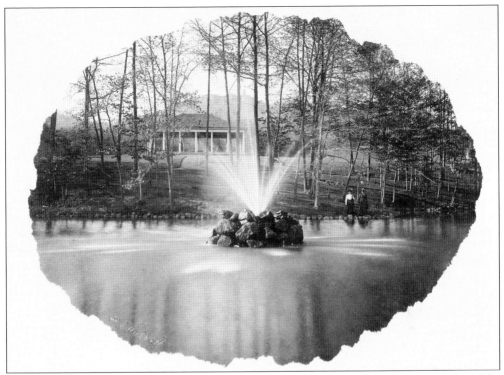

FOUNTAIN IN LILY POND. In this early-20th-century image, two women stand near the edge of the lily pond admiring Egyptian lotus and the beautiful water sprays from a fountain, one of Hubbard Park's earliest centerpieces. In the background, the Grecian Temple sits just beyond a grassy lawn. Castle Craig Tower is visible in the distance. (Courtesy of Meriden Historical Society.)

"MAN IN THE STONES." Pictured is the late Meriden historian Dan W. DeLuca pointing out the Face Rock, from the Man in the Stones. This oblong rock, shaped like a head, once contained embedded glass marbles for eyes. Although somewhat hidden within the arch of a stone drain, it is one of Walter Hubbard's whimsical accents along the north end of Hubbard Park Drive. (Courtesy of the *Record-Journal*.)

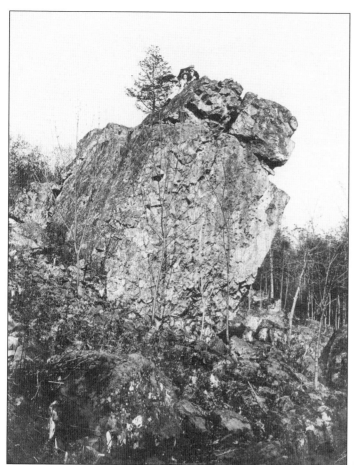

GIANT'S PLAYGROUND. A family of three poses atop a rock in the park's Giant's Playground. West of Fairview Point, this "playground" refers to the great crags of detached stone scattered throughout the area. The name may be a response to the neighboring Sleeping Giant, a different set of rugged traprock mountains bearing a resemblance to a slumbering figure, some 17 miles away in Hamden.

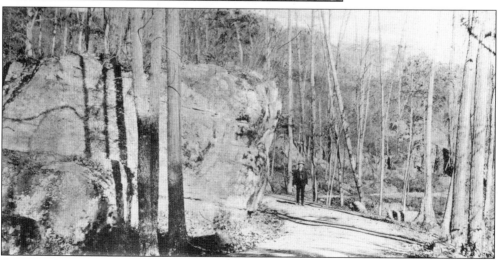

BOULDER BLUFF. On a pathway west of Fairview Point, there is a route named Boulder Bluff. This winding trail features wild scenery, magnificent views of the park, and overlooks of the city. Named for its unique rock formations, Boulder Bluff provided an additional entrance into the park as Fairview Point grew in popularity.

ROBERT F. MORRISSEY. Before coming to Meriden, English-born Robert F. Morrissey was a florist. He carried his love for flowers to Meriden and built a greenhouse at his Webster Street home. Well acquainted with Walter Hubbard, Morrissey often inquired about developments within the park and was hired as a mason to help build Castle Craig Tower. Morrissey later succeeded Patrick J. Quigley as Meriden's second superintendent of parks. He died in 1931.

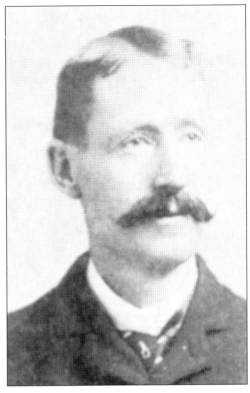

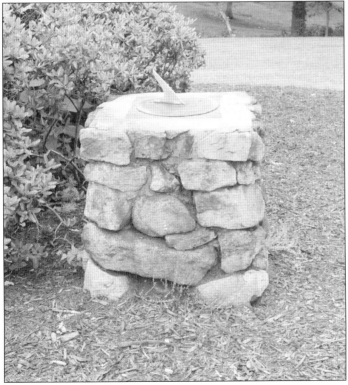

THE HUBBARD PARK SUNDIAL. A bronze sundial stands atop a fieldstone pedestal near one of the park's first entrances. Over the last century, it has weathered the elements, survived vandalism, and even endured a speeding car in 2002. Made by the Bradley & Hubbard Manufacturing Company, it proudly bears the mark "1902." Upon its faded brass surface is a clearly visible, whimsical inscription: "Among the trees and flowers, I tell the sunny hours."

45

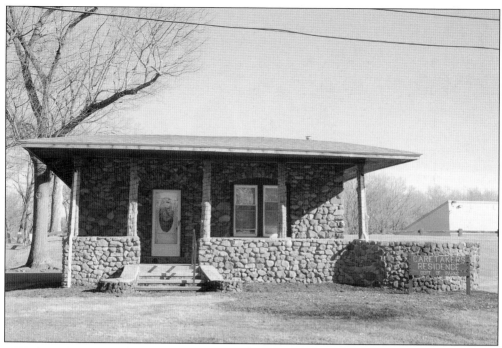

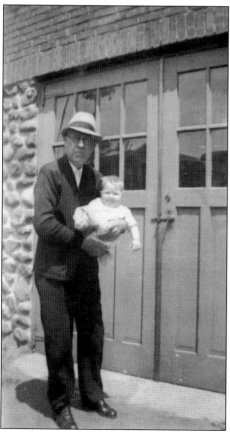

CAHILL HOME REBUILT IN STONE. The Cahill family lived in a private home neighboring Hubbard Park for years before the park was built. Around 1905, Thomas Cahill Sr. (pictured at left holding granddaughter Maureen Cahill in 1940) tripped while going down the inside stairs with a kerosene lamp and burned the home to the ground. When it came time to rebuild, Walter Hubbard—who owned Park Way—would not allow construction vehicles onto the road to the property. Unbeknownst to Hubbard, Cahill contacted local contractor Leonardo Suzio and had materials secretly delivered under the cover of night. The current stone house was built quickly with no fuss from Hubbard. According to a Cahill descendant, Cahill considered operating an ice cream parlor at the cottage, planning to use the large front porch and its three entrances for tables for patrons. Given Walter Hubbard's opposition to concessions in the park, this proposal may have been an attempted retaliation for Hubbard not allowing construction vehicles onto Park Way. The plan for an ice cream parlor was never realized, and the stone cottage served as the home for the Cahills, the Barrys, and later park watchmen. The house is now part of the park itself and is known as the Caretaker's Residence. (Both, courtesy of Kevin Quinlan.)

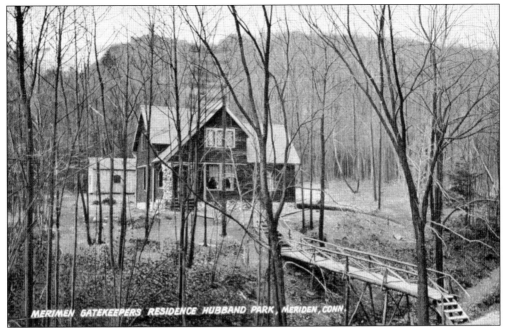

GATEKEEPER'S RESIDENCE. After the death of Merimere Reservoir caretaker George Heil in 1900, the city and the public works department built this two-story home for the reservoir's gatekeeper. It was set back along the road to the reservoir and shielded by trees. Rumors remain that this home may have been relocated to West Main Street. Shown in this c. 1907 postcard, the residence stood where the reservoir's water treatment plant is today.

FIRST HUBBARD PARK REMODELING. Frank St. George succeeded Robert F. Morrissey as superintendent of parks. Hailing from Italy, St. George came to America at the age of 20 and resided in Meriden for over 50 years. Very active in Meriden politics, he became superintendent under the administration of Mayor Daniel J. Donovan and again under Mayor Walter Lines deBussy. He was instrumental in the initial remodeling of Hubbard Park in the 1920s, as seen in this picturesque winter scene.

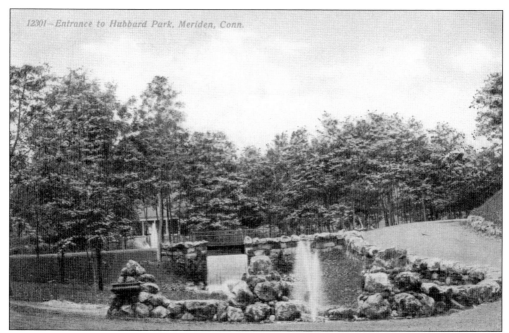

12301—Entrance to Hubbard Park, Meriden, Conn.

POSTCARD FLIGHT. A similar postcard of the Hubbard Park bridge and entrance waterfall was received in Meriden by Walter Psoter after it traveled around the world on the *Graf Zeppelin* airship. The card was mailed by the boy's father, Carl Psoter, on August 5, 1929, and it reached Lakehurst on August 29 of that year. The total postage was $1.78.

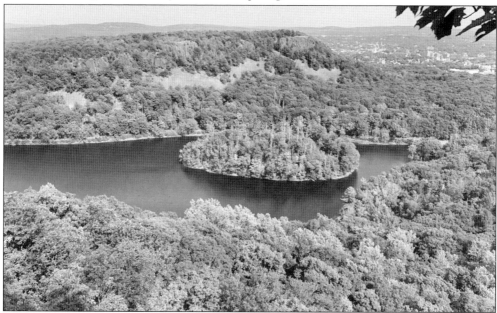

MERIMERE RESERVOIR AND MINE ISLAND. In this photograph, the Merimere Reservoir surrounds Mine Island on the north side of Hubbard Park. This uninhabited island got its name from the age-old belief that the area was rich in minerals, even gold. However, local entrepreneurs like former landowner William Johnson found no such precious metals, other than small quantities of iron pyrite. (Courtesy of Erik Remillard.)

48

Three

EAST PEAK

Castle Craig Tower, the famed 32-foot stone overlook atop Hubbard Park's East Peak, is an ever-present reminder of Walter Hubbard's generosity.

Built between April 30 and October 29, 1900, the tower is constructed of the native traprock that forms the Hanging Hills and East Peak. It was designed by architect and Bradley & Hubbard draftsman David Stuart Douglass and constructed by masons William Moses Sr. (foreman), Levi Moses, Robert Morrissey, Paul Tambourine, and others. The tower is a testament to their design skills and craftsmanship.

At the time of its construction, Castle Craig Tower was referred to as the Tower. The name Castle Craig was not popularized until much later, sometime in the mid-20th century. The origins of the name are debated. Was it used to reference the Scottish word *crag*, meaning "steep, rugged rock," or was it used to help identify the tower's likely design origins in Craigellachie, Scotland?

The traprock exterior of the tower has changed only slightly since its construction, but the interior has seen a multitude of renovations. Originally, visitors had to climb a nearly vertical interior ladder to reach the observation floor at the top of the tower. In the early 1930s, the ladder was replaced with a more sturdy and easy-to-climb metal staircase. In 1933, the original single-bar horizontal iron rods between the crenulations, installed to protect visitors from falling, were replaced with iron grills for greater safety.

Whether the ascent to the observation level was made by ladder or stairs, it was and still is worth the effort. Sitting atop the 976-foot East Peak, Castle Craig Tower provides a stunning view of Meriden, Cheshire, Wallingford, and other surrounding towns from more than 1,000 feet up. When the air is clear, it is possible to see as far as New Haven and the dark outline of Long Island to the south along with the pale, faint outline of the Green Mountains of southern Massachusetts to the north. It also has the distinction of being the highest point within 25 miles of the coast from Maine to Florida.

More than a century after its historic dedication on October 29, 1900, Castle Craig Tower remains Meriden's foremost landmark. Its beauty continues to bring pride to those down below its perch on East Peak.

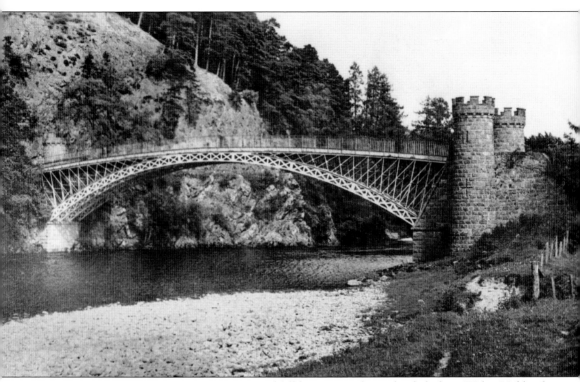

CASTLE CRAIG TOWER'S ORIGINS. Rumor and folklore seem to have clouded where Walter Hubbard got the idea for Castle Craig Tower. Most agree that the inspiration can be traced to Hubbard's early travels abroad. Although the tower's construction resembles Norman watchtowers, it appears that the tower was designed after a bridge in Craigellachie, Scotland (pictured). In a November 23, 1923, *Meriden Record* article about repairs to Castle Craig Tower's stairway, Mayor Henry T. King stated that the tower was patterned after a tower in Scotland. This is the earliest known reference to the tower's design source, and as Hubbard's attorney and a member of the park commission for many years, King would have been a reliable source of information. His claim was corroborated by Ruth Douglass, daughter of tower architect David Stuart Douglass, decades later. The confusion may have started with a November 10, 1949, letter from Charles B. Welch, David Stuart Douglass's brother-in-law, to *Meriden Record* publisher Wayne C. Smith. In the letter, Welch said the tower was a replica of an old Norman tower. The Craigellachie Bridge, with its distinct stone towers, was an engineering marvel in the 19th century and remains a landmark today; it is possible that Hubbard saw or heard about the bridge during his travels to Europe.

CASTLE CRAIG TOWER. In this autumn 1900 photograph, men and women stand atop Castle Craig Tower. Taken by renowned Meriden photographer Burton H. Hubbell, this image is one of the first showing visitors to the top of the new lookout tower. The city of Meriden can be seen to the right in the distant valley, partially obscured by haze. (Courtesy of the Meriden Historical Society.)

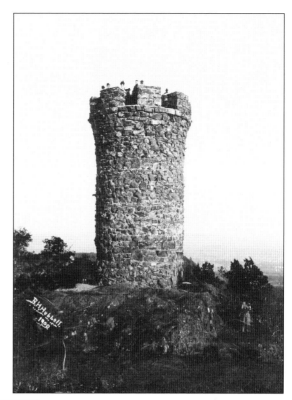

DAVID STUART DOUGLASS. David Stuart Douglass was born in Wallingford, Connecticut, in 1880. Upon graduating school, he was hired by the Bradley & Hubbard Manufacturing Company as a draftsman. Douglass befriended Walter Hubbard, who soon chose the 20-year-old draftsman to design and supervise the construction of the 32-foot-high Castle Craig Tower for the summit of East Peak, in addition to other park structures. Douglass died in West Hartford in 1944.

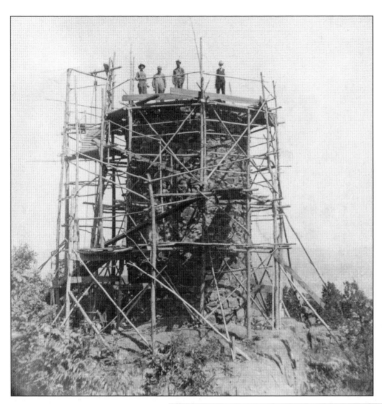

EARLY CONSTRUCTION OF CASTLE CRAIG TOWER. On Monday, April 30, 1900, Hubbard laid the first stone for his observation tower. Builders commenced construction along the east ridge of East Peak under the supervision of foreman William Moses Sr., pictured here at far right. This photograph shows the system of scaffolding, platforms, and ramps used to construct the traprock tower. (Courtesy of the Meriden Historical Society.)

CASTLE CRAIG TOWER. Three years after construction of Hubbard Park began, preparations were made to build this stone observation tower. Construction proved to be challenging as it required the building of roads for carriages transporting supplies and visitors up the mountain and the creation of paths for pedestrians. It took nearly six months to build. The nearly completed tower is seen here in the final days of construction in October 1900. (Courtesy of the Meriden Historical Society.)

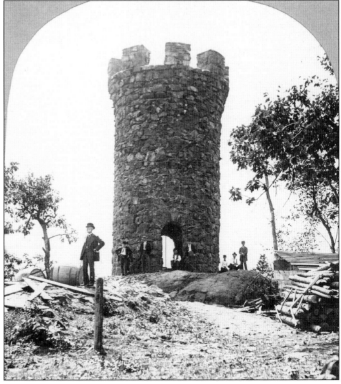

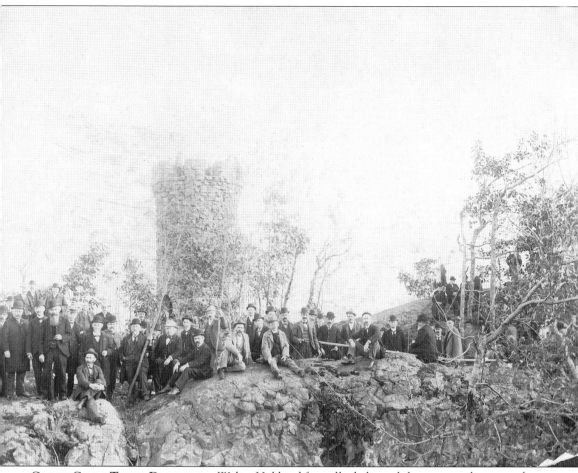

CASTLE CRAIG TOWER DEDICATION. Walter Hubbard formally dedicated the tower and presented it to the City of Meriden on October 29, 1900. The *Meriden Daily Journal* provided an account of the day's festivities:

A large number of members of the Court of Common Council, together with other dignitaries, attended an oyster roast in the shadow of the Tower. Westbound trolleys were crowded with citizens who used this form of transportation to the park area from where they had a long and arduous trek, on foot, to the tower. There were also a number of citizens who drove to the top of the mountain in their own carriages. At 2:00 p.m., it was estimated that approximately 250 guests were in attendance. Their generous host, Walter Hubbard, had provided six barrels of oysters and a barrel of clams. These were roasted over a big fire under the direction of C.W.F. Pardee of the Winthrop Hotel and P.J. Quigley, a local contractor, with the assistance of twelve men. The Tower itself was the center of attraction and nearly everyone had something to say concerning the beautiful scenery and Mr. Hubbard's benevolence.

(Courtesy of the Meriden Historical Society.)

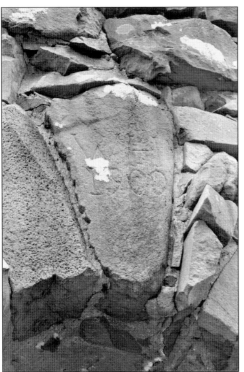

WALTER HUBBARD'S INITIALS. Some believe that after the completion of Castle Craig Tower, Walter Hubbard chiseled his initials and the dedication year in the keystone above the tower's entrance. Camouflaged slightly, the "WH 1900" has quietly welcomed countless visitors for more than a century.

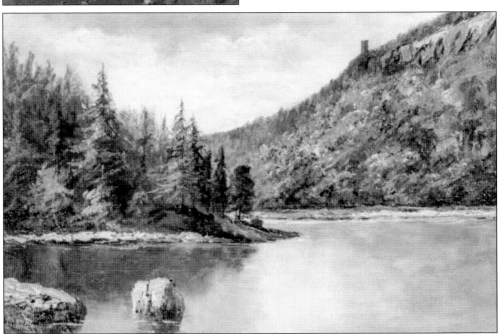

FREDERICK MATZOW. Local artist Frederick Matzow was inspired by his environment. In this 1914 oil-on-canvas landscape entitled *Castle Craig*, the tower is shown perched upon the edge of East Peak as seen from the shores of Merimere Reservoir below. Meriden's artist-in-residence, Matzow primarily worked as a freelance artist but was also employed by the John R. Hall Company and the famed Handel Lamp Company. (Courtesy of Peter Wnek.)

Four

WEST PEAK

Many assume the Hanging Hills have always been an unsettled, natural landscape. However, as far back as the mid-18th century, this land has been home to a number of residences and was a stage for important events and legends. This is especially true for West Peak.

West Peak has been prime real estate for centuries. A Connecticut Whig newspaper post from February 19, 1853, reported that W.J. Cadwell of Hanover was constructing a road and a resort atop West Peak, outfitting his hotel with an impressive "telescope of great power." By the Civil War, the West Peak House and ongoing interest in West Peak had attracted a colony of new residents. This increased development generated interest in constructing a larger settlement on the mountain. In March 1888, Henry N. Johnson, heir to the William Johnson estate, devised a plan to construct a hotel, public park, and resort houses on the peak. As word spread about Johnson's plan, prominent locals quickly purchased land on the highly desirable peak and built their own three-season residences. This development and others motivated Walter Hubbard to purchase West Peak land in an effort to preserve the natural landscape of his future park.

West Peak has also been host to important events. In 1858, it was the site of an enormous fireworks presentation celebrating the completion of the Atlantic cable running between North America and Europe. In 1876, a grand Independence Day fireworks display on West Peak celebrated the nation's centennial; Charles Parker's mule teams brought a dozen barrels of rosin, lumber, and other combustibles to the peak for an elaborate display. In the early 1900s, the peak became a destination for people suffering from polio who were seeking higher elevations. Decades later in the 1930s, the peak was home to a school for the extermination of the invasive gypsy moth.

Aside from the radio antennas that now tower above West Peak, Meriden residents today know West Peak for its legends. Stories of the Old Leather Man and his mountainside shelter and the mysterious black dog who appears to visitors for joy, sorrow, and death are important in Meriden's local lore.

Although East Peak, with its Castle Craig Tower, is the more prominent mountain in today's Hubbard Park, West Peak has played an equally important role in the creation of the park, landscape, and local legends.

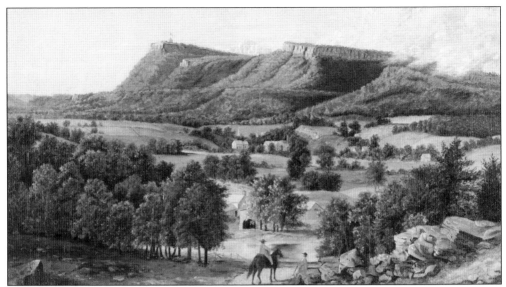

VIEW OF THE HANGING HILLS AND THE WEST PEAK HOUSE. In this 1855 painting depicting Meriden and the Hanging Hills from the southwest, W.J. Cadwell's West Peak House hotel can be seen at left center atop West Peak beneath the large US flag. This resort hotel operated from 1853 to 1866 and boasted a large telescope that provided visitors spectacular views from the 1,000-foot peak. (Courtesy of the Connecticut Historical Society.)

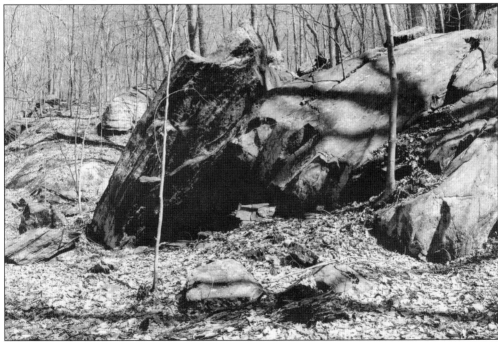

OLD LEATHER MAN'S CAVE. The Old Leather Man was a vagabond who consistently traveled a 365-mile circuit between the Connecticut and Hudson Rivers from roughly 1857 to 1889. Living in caves and rock shelters like this one on the Southington side of West Peak, he stopped at towns along his route every five weeks for food and supplies. He was called the Old Leather Man for his clothes and shoes, which were handmade of leather.

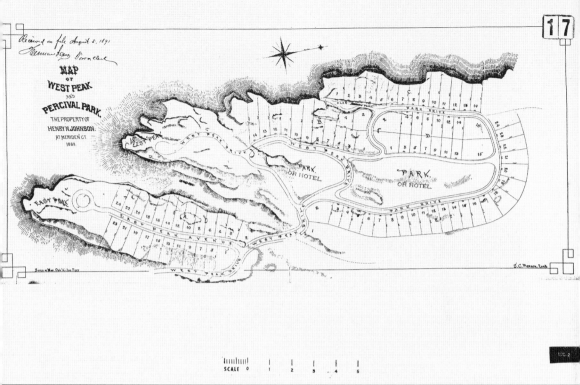

PERCIVAL PARK. In 1889, Henry N. Johnson had plans submitted for a resort on his property and neighboring parcels along the top of West Peak. The proposed resort was to be called Percival Park and would be complete with both an elaborate carriage drive and walkway, in addition to electric car transportation to the peak. Sometime later, this proposal generated great interest to the founders of Mount Tom in Massachusetts, who initiated talks to manage the upcoming resort. As plans were being considered, affluent residents recognized the opportunity for development on West Peak and quickly purchased adjacent property. These plans upset Hubbard, who was purchasing nearby land for Hubbard Park; he knew that development of this prime land would ruin the park's natural beauty and water supply. In response, he purchased land near the proposed development to preserve the landscape. His efforts successfully prevented the construction of Percival Park. Today, nearly all traces of this park are gone, and the West Peak communication towers now occupy the proposed site of Percival Park.

OWEN ARNOLD AND FRANCIS ATWATER.
Owen B. Arnold (left), a prominent Meriden banker, owned a substantial amount of property surrounding West Peak. Walter Hubbard feverishly requested that Arnold rethink his plans for developing this land and sell it to him. Although the two had previously served together as city councilmen, they did not get along, and Arnold was adamant that his land should never get into Hubbard's possession. Years later, he negotiated a deal with local journalist and budding businessman Francis Atwater (below), who wanted to purchase the West Peak property for the Southington Electric Road. The $10,000 purchase fell through, and Arnold died soon after. Atwater later acquired the land in addition to 13 acres lower down the mountain with plans to build an electric road to the top. These plans never succeeded, and Hubbard ultimately acquired the land for the park.

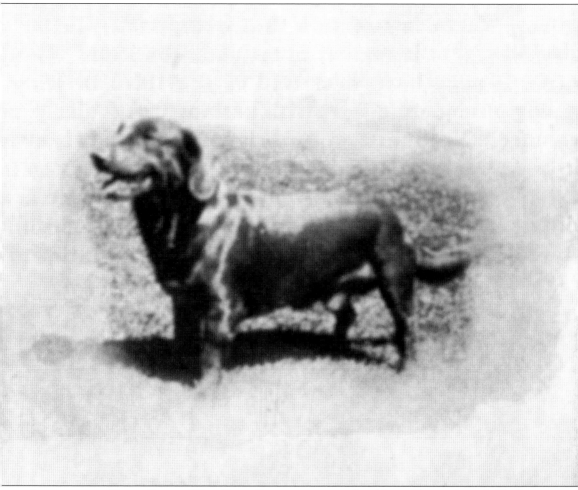

LEGEND OF THE BLACK DOG OF WEST PEAK. For over a century, local legend has spoken of a black dog that wanders West Peak and Hubbard Park. The first non-local account of this legend was by W.H.C. Pynchon in "The Black Dog," published in the *Connecticut Quarterly* in 1898. His article opens with: "And if a man shall meet the Black Dog once, it shall be for joy; and if twice, it shall be for sorrow; and the third time he shall die." In February 1891, Pynchon and geologist Herbert Marshall of the United States Geological Survey were conducting research on West Peak. According to Pynchon, he had seen a mysterious black dog during a previous visit while Marshall had seen a similar dog twice during previous trips. On this particular winter day, the black dog appeared to the men on a cliff not far from where they stood. Moments after spotting the dog, one of the rocks beneath Marshall let go, and he slipped off the cliff and disappeared. Pynchon searched for his friend, but by the time he found him it was too late. He sought the help of nearby farmers, who recovered the body. This photograph of a black dog was featured in Pynchon's article. There have been at least six deaths attributed to seeing the black dog three times.

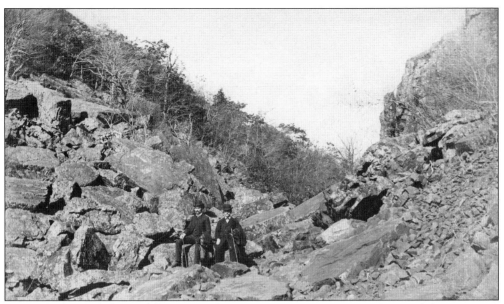

THE VALLEY OF THE SHADOW OF DEATH. The cragged traprock slopes of the notch between East and West Peaks were nicknamed "The Valley of the Shadow of Death." This name was given by W.H.C. Pynchon in his article "The Black Dog" after Herbert Marshall fell to his death in 1891, allegedly after his third sighting of the mysterious dog. Sitting amongst the talus and rubble of this valley, these dapper gentlemen may have been pondering the truth behind these tales.

QUARANTINE

POLIOMYELITIS

All persons are forbidden to enter or leave these premises without the permission of the HEALTH OFFICER under PENALTY OF THE LAW.

This notice is posted in compliance with the SANITARY CODE OF CONNECTICUT and must not be removed without permission of the HEALTH OFFICER.

Form D-1-Po. _____Health Officer.

POLIO CARAVAN HEADS TO THE PARK. Poliomyelitis, or polio, did not attract attention in Meriden until a slight outbreak in June 1910. During the outbreak, families were told to isolate themselves in their homes. Those with severe cases were instructed to move to higher elevations for the air. That year, a caravan of automobiles could be seen carrying wealthy residents with polio to the Hubbard Park peaks.

"WEST PEAK COLONY." Cornelius Danaher, William Catlin, Levon Kassabian, and Wilber Henry Squire were four prominent Meriden residents who owned recreation and summer homes atop West Peak in the latter part of the 19th century; together, they were known as the West Peak Colony. Pictured here is Catlin's Katelyn Kottage, the first of the homes to be built. In later years, the cottage was used as a YWCA vacation home.

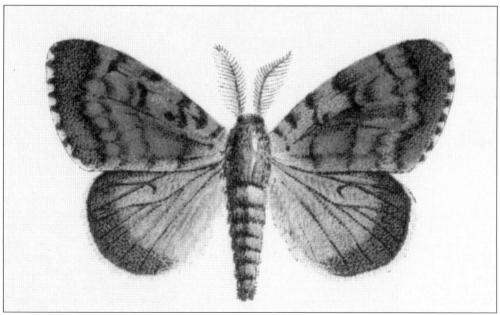

EXTERMINATING THE GYPSY MOTH. In 1933, the invasive gypsy moth devastated trees throughout New England. To combat this infestation, the federal government selected 80 unemployed young men to learn the art of exterminating the insect at a new school atop West Peak. Once trained, they were sent to area farms and even other states to help with eliminating the pest.

WEST PEAK TOWER. The original West Peak tower was built for experiments and demonstrations of the new frequency modulation method of sending radio signals, known today as FM radio. One of the first experimental FM radio station broadcasts was transmitted from "Radio Mountain" on October 2, 1939. This station, first designated as WIXPW, participated in FM radio inventor Edwin H. Armstrong's demonstrations of relaying FM radio signals from New York to northern New England in 1940.

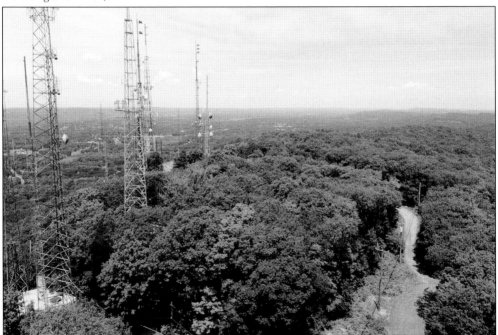

WEST PARK COMMUNICATIONS. Today, along the westernmost ridge of West Peak, a 165-acre parcel is leased to two dozen broadcast companies for antennas and towers. The location is desirable because of the height of West Peak, 1,200 feet above sea level. West Peak is also the location of a National Weather Service radio station. (Courtesy of David De Lancey.)

Five

MERIDEN'S
GATHERING PLACE

Hubbard Park has been a place for rest, recreation, and gathering since its construction at the turn of the 20th century. More than 100 years later, Hubbard Park continues to be an asset to the people of Meriden and the region.

Before the park officially opened in 1898, visitors were already enjoying its beautiful landscape. Summer weekends attracted hundreds and soon thousands of visitors. In 1901, the advent of a trolley line that stopped at the park created an even greater surge in attendance.

America was changing quite rapidly during this period. Major advances in science and medicine were coupled with developments and growing interest in culture, fashion, sports, and recreational activities. Locations like Hubbard Park were places for relaxation and offered new opportunities for recreation. As vaudeville performances, dance halls, and motion picture showings grew in popularity, so did the appeal of escaping urban settings for picturesque open-air parks.

As one of the largest and most magnificent parks in New England during this time, Hubbard Park was an ideal and inspiring place to gather. Miles of fine drives and trails provided recreation, scenic viewpoints, and picnicking locations for people of all ages The park's network of streams, ponds, and lakelets created beautiful landscapes to explore and even introduced water-based activities. Historically and today, the park's scenery and adornments—both natural and man-made—have become iconic backdrops for drawings, photographs, and films that memorialize special visits to Hubbard Park.

Hubbard Park has also been a favorite recreation spot. Over the years, thousands of local and out-of-town visitors have taken advantage of the park's two pools, three tennis courts, ball fields, and play areas. Mirror Lake has supplied year-round activities from fishing and boating to ice-skating and barrel jumping. The Hubbard Park Grecian Temple and the James J. Barry Bandshell continue to provide a venue for music and entertainment.

Whether for picnics, parties, outdoor recreation, or even festivals, Hubbard Park has become one of the region's signature places for gathering.

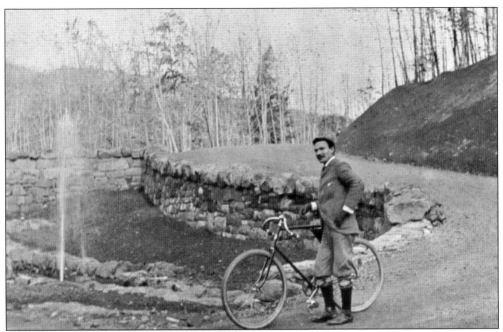

BICYCLES IN THE PARK. With the rising popularity of the bicycle in the late 19th century, Walter Hubbard recognized the importance of cycling paths throughout the park. As early as 1897, Hubbard Park was suitable for cycling. Here, E.L. Abbott stands proudly at the unfinished entrance to the park, perhaps just moments before or after a ride to observe the park's construction. (Courtesy of Allen Weathers.)

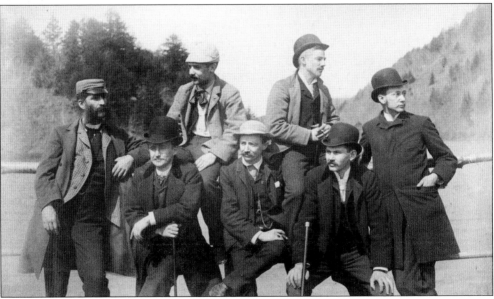

WALKING STICKS IN VOGUE. In early images of Hubbard Park, male visitors are often pictured with their canes or walking sticks, which were quite fashionable in the late 19th century. Here, a group of young men pose in front of Merimere Reservoir with two of them prominently showing their walking sticks.

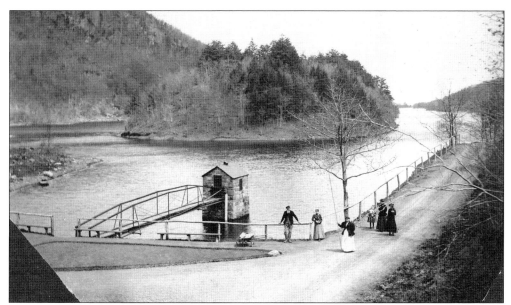

MERIMERE RESERVOIR. As Meriden's population grew in the 19th century, the need for an adequate municipal water supply became more apparent. Meriden soon acquired the rights to a reservoir site among the Hanging Hills on the west side of the city. In 1869, the Merimere Reservoir was authorized, and by 1873, it was in full operation. Not only did the reservoir supply water, it was also a place for recreation. This late 1890s photograph shows a group of visitors with long fishing rods just after fishing along the shores of the reservoir. (Courtesy of the Meriden Historical Society.)

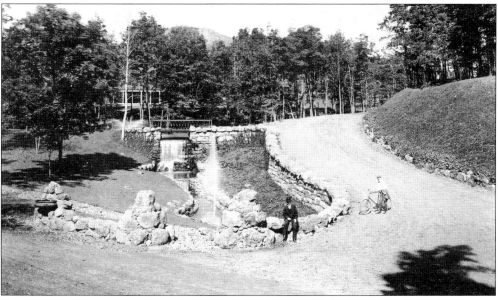

CASCADE AND FOUNTAIN AT PARK ENTRANCE. In this c. 1898 photograph of the park, one man sits upon a rock wall and another poses beside his bicycle at the original Park Way entrance to Hubbard Park. To the left of the seated man, a gravity-fed fountain sprays water high above the small pond in the foreground. Nearby, a cascading waterfall flows beneath an iron bridge and over ivy-covered stones. The park's recently completed Grecian Temple is visible in the distance. (Courtesy of the Meriden Historical Society.)

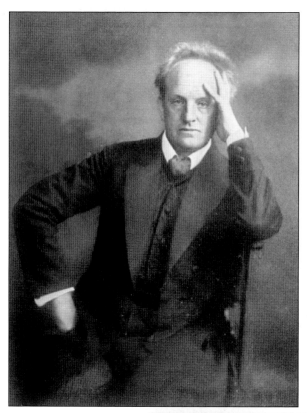

The Sunken Bell. The beauty of the Merimere Reservoir, nestled between East Peak and South Mountain, inspired Germany's romantic dramatist Gerhart Hauptmann (pictured). During the latter years of the 19th century, Hauptmann visited his friend Dr. Alfred Ploetz in Meriden. Impressed by the hills and the waters of the reservoir, Hauptmann conjured up a Brothers Grimm–like setting for one of his best-known dramas, *The Sunken Bell.* He later received the Nobel Prize in literature in 1912.

A Drink from a Hubbard Park Canal. In this 1898 photograph, a thirsty man sneaks a sip from the Maloney Canal. Located at the northern end of the Merimere Reservoir, this channel feeds Merimere Reservoir with runoff from the East and West Mountains. As one would walk or drive over the Reservoir Dam and begin the incline toward Castle Craig Tower, the canal empties into the reservoir on the left where the woods meet the water; it remains on the left of the road for most of the ascent up the mountains. (Courtesy of Allen Weathers.)

CONGREGATIONS AT THE PARK. Hubbard Park hosted its first picnics in June 1898. Local church groups, fraternal organizations, and societies found the park welcoming, and it soon became a popular place for group gatherings. In this c. 1899 photograph, a group of young ladies clad in white dresses poses on the Civil War mortar, once located on a hill near the Grecian Temple, to document their visit to the park. (Courtesy of Allen Weathers.)

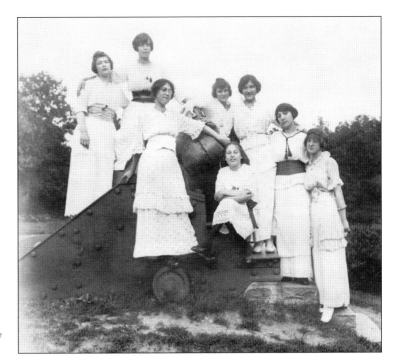

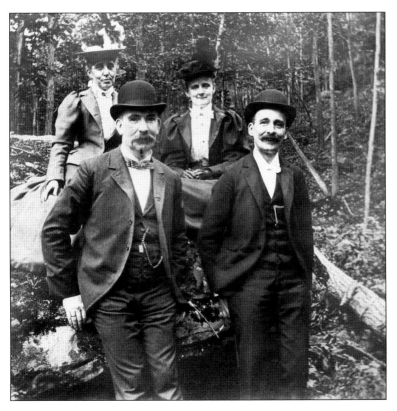

COUPLES POSE IN BOULDER BLUFF. George Davis, Henry Vibert, and their wives pose on top of a rock in Boulder Bluff on October 2, 1898. Boulder Bluff is an overlook just west of Fairview Point. These couples may have witnessed construction of the carriage road to Fairview Point along the western side of Cliff Drive, which had begun only a few weeks prior. (Courtesy of Allen Weathers.)

MIRROR LAKE. This early photograph shows a man holding a long branch over the waters of Mirror Lake, the park's centerpiece. This image clearly shows the trees, brush, and overgrowth that once dominated the perimeter of Mirror Lake; the walls along the edges of the pond were not constructed until decades later. With a view to the north, the crest of South Mountain is visible in the distance.

SHALLOW MERIDEN RESERVOIR. A well-dressed man stands along the rocky bank of a long and shallow Merimere Reservoir in this undated photograph. To the left, a rustic iron bridge leads to the gatehouse where a measuring stick shows less than four feet of water in the reservoir. Leafless trees and pines can be seen behind the gatehouse on Mine Island and lining the embankment to the right. (Courtesy of the Connecticut Historical Society.)

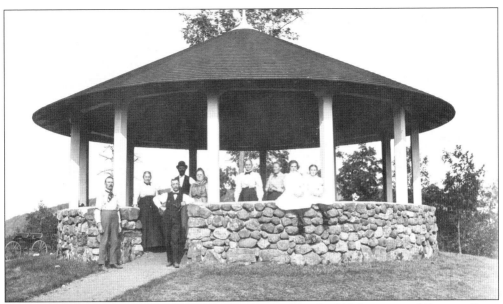

FAMILY OUTING AT FAIRVIEW POINT. Family outings upon the 500-foot crest of Fairview Point were common during the park's early years. After a walk or carriage ride along Cliff Drive, families could play in the well-manicured landscape of the Fairview Observatory, or enjoy scones, apples, cake, and other typical picnic foods of the period. (Courtesy of the Meriden Historical Society.)

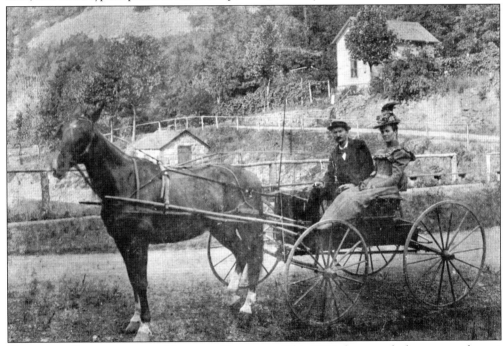

HORSE AND CARRIAGE AT THE MERIMERE RESERVOIR. This 1899 photograph shows a couple next to Merimere Reservoir near the entrance to the park's scenic pathway, Cliff Drive. This inclined pathway was the preferred route to the Fairview Observatory pavilion. In the background, just above the horse's back, is the reservoir's gatehouse; the house of reservoir watchman George Heil is to the right. (Courtesy of Allen Weathers.)

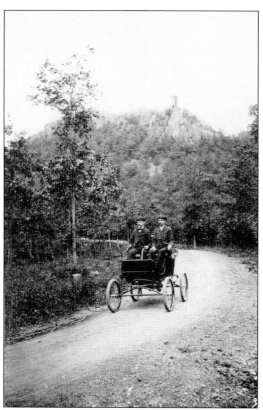

EARLY CAR IN HUBBARD PARK. The automobile became the preferred method of transportation in the early 20th century. In 1900, only six Meriden residents claimed to own a "horseless carriage," but by 1906, the state registry reported more than 100 automobiles owned by Meriden residents. Two men enjoy a leisurely drive in the park in this photograph, with Castle Craig Tower rising high atop East Peak in the distance. (Courtesy of Allen Weathers.)

FAIRVIEW OBSERVATORY AND CASTLE CRAIG. In this 1900 photograph taken by the Meriden Gravure Company, Walter Hubbard stands inside the Fairview Observatory with the Castle Craig Tower rising gracefully in the distance atop East Peak. Hubbard used this image in promotional materials for the park. It was later made into postcards by Meriden stationery store owner August Schmelzer.

EDWIN AUGUSTUS MOORE. Born in Kensington, Connecticut, in 1859, Edwin Augustus Moore was the firstborn son of renowned New England artist Nelson Augustus Moore. Unlike some turn-of-the-century artists who abandoned painting for photography, this father and son continued to paint Connecticut scenes. In this graphite-on-paper landscape, the younger Moore depicts the pond and footbridge found at the Park Way entrance to Hubbard Park. (Courtesy of the Connecticut Historical Society.)

A GATHERING ATOP EAST PEAK. The heat of the summer months took its toll on Hubbard Park visitors like these who made the trek to the top of East Peak and Castle Craig Tower. Walter Hubbard, in an effort to provide comfort to park guests, had an icehouse built on East Peak to store 25 tons of ice and offer visitors a cold, refreshing drink. This short-lived icehouse is just out of view in this picture.

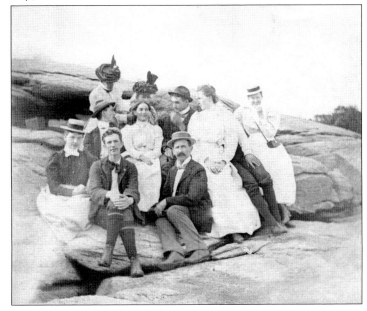

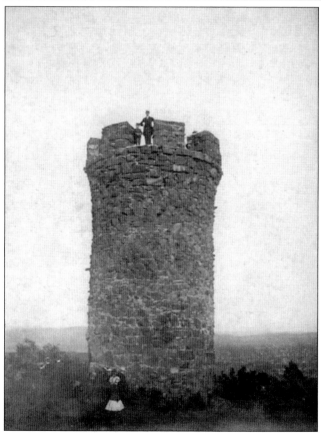

THREE MEN ALONG CLIFF DRIVE. This photograph was included in Walter Hubbard's promotional booklet *Hubbard Park*, published in 1900. It shows three men and a horse and carriage traveling along a southerly slope of Cliff Drive. Having driven through Boulder Bluff and passing the Beehive Spring, this group was en route to Mirror Lake and the lower areas of the park.

CASTLE CRAIG TOWER. Just days after Hubbard Park's formal dedication in October 1900, a massive bonfire and party were held at Castle Craig Tower to celebrate Pres. William McKinley's reelection. In this photograph, park visitors enjoy the tower's breathtaking views, although cautiously, as its railings were not yet installed.

A Beehive Spring. It is not known why Walter Hubbard chose to use the beehive motif throughout the park, particularly for the structures marking the park's springs, but they became iconic features. Here, Hubbard himself drinks from a beehive spring while his traveling partner waits a short distance up the path. Today, this last beehive spring remains on the trail to Castle Craig Tower.

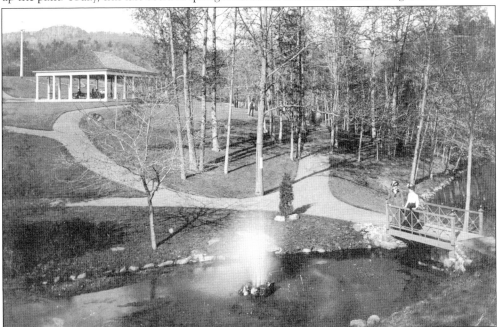

Rustic Bridges Taking Shape. Two women converse upon one of the park bridges adjacent to the main entrance. Only a few months into construction, visitors could see the emerging beauties of the soon-to-be park. Ponds were unveiled, preparations were made for the cascade waterfalls, and the rustic iron bridges were built. The bridges, along with all other park metalwork, were likely designed by Castle Craig Tower architect David Stuart Douglass and produced by the Bradley & Hubbard Manufacturing Company.

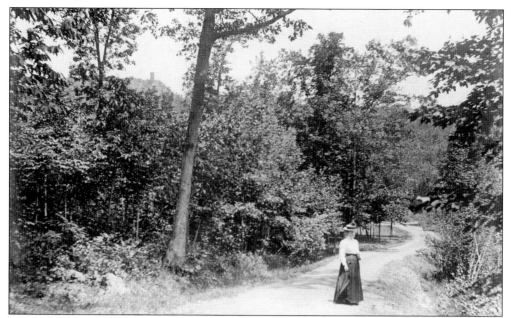

WOMAN ON PARK WAY. In this early photograph from Independence Day 1901, a woman stands along Park Way, the main road into the park, just past the entrance and waterfall. The stone wall that lines Park Way today was added many years later. Carriages were not allowed into the park, so they were routed up this road to circle around to an open parking area to the right, just beyond the frame of this photograph.

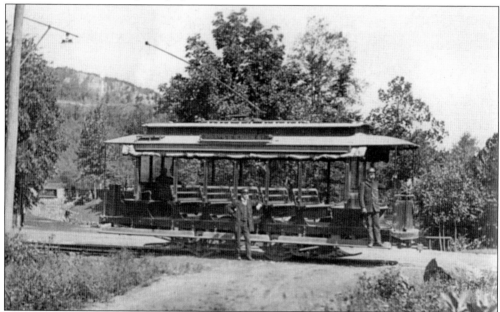

STREETCAR TO HUBBARD PARK. By the end of the 19th century, a growing network of trolley lines across the city made it possible for people to reach the park via public transportation. Pictured on the south side of Meriden-Waterbury Road, today's West Main Street, is the Pratt & West Main Street trolley, which made a stop at Hubbard Park. For 5¢, visitors could reach their destination via the local streetcar.

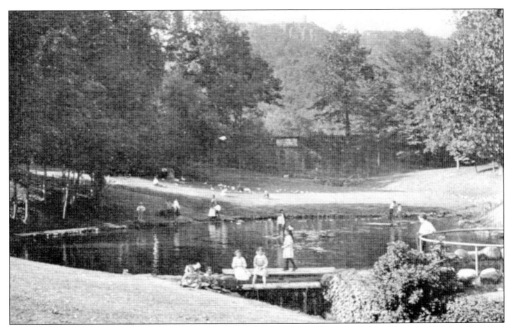

CHILDREN'S PLAYGROUND. Just below Mirror Lake lies a smaller pond that Walter Hubbard called the Children's Playground. The pond was designed for wading, with a depth of 18 inches. Nearby, a playground with swings, a goldfish pond, a dovecote, and a squirrel cage each added to the excitement of this unique children's area. It is easy to see why the banks were always crowded with families and children.

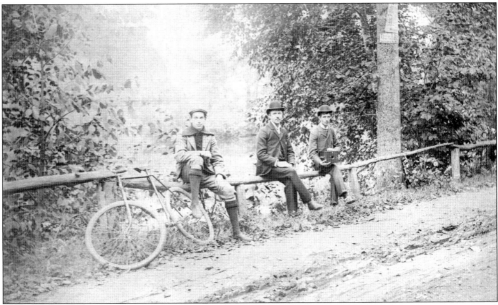

PHOTOGRAPHY IN THE PARK. By the early 20th century, photography became more accessible and was enthusiastically embraced by the public. With the advent of small, handheld box cameras, it was possible for the middle class to take their own photographs. As Hubbard Park grew in popularity, it became a prime location for photography. This picture shows three men relaxing on a tree railing beside the Merimere Reservoir. The man at far right is holding one of the new cameras.

Drinking Cups at the Beehive Fountains. Walter Hubbard saw a need for drinking cups at the open beehive springs throughout the park. The man next to the spring in this photograph is likely using one of the cups that Hubbard provided. Unfortunately, visitors vandalized the cups and scattered them across the park. Hubbard tried attaching the cups to the fountains, but in 1904 decided to remove the cups altogether, requesting that visitors drink directly from the open spring. (Courtesy of Seth Eddy.)

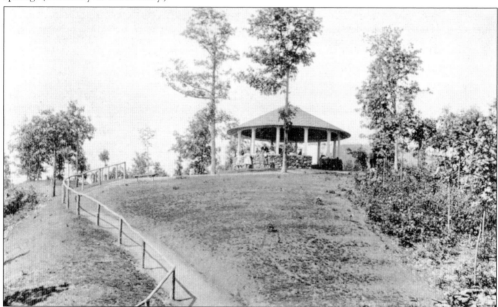

The Landscape of Fairview Point. Early park photographs show neatly trimmed grass and well-kept pathways, particularly around structures like the Fairview Observatory. For years prior to the construction of Hubbard Park, trees were cleared from this land for firewood. Images like this early 1900s photograph show trees just starting to grow back, providing picturesque backdrops for picnics and unobstructed views from elevated park trails and peaks.

GIRL AND MORTAR. In this turn-of-the-20th-century photograph, a young girl dressed in white stands in contrast to the dark and imposing Civil War–era mortar. Once an iconic landmark in the park, this cannon was placed on a stepped foundation atop a hill near the Grecian Temple. It was intentionally positioned to be visible from the entrance and other areas of the lower park. At each corner of the gun's base was a pile of four stacked cannonballs.

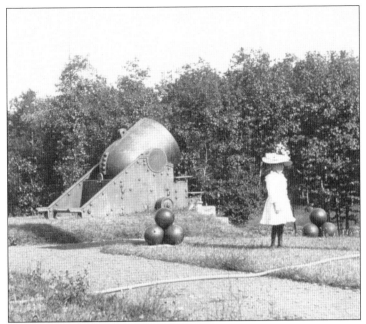

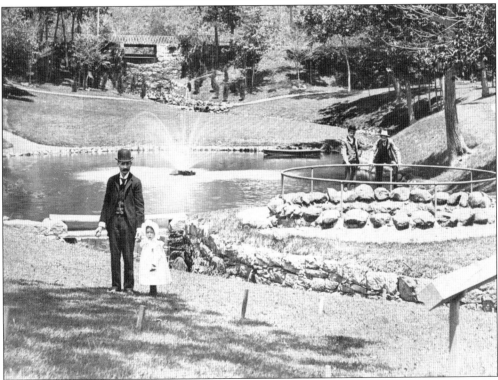

FATHER AND DAUGHTER EXPLORE THE CHILDREN'S PLAYGROUND. A father poses with his daughter along the edge of the Children's Playground, sometimes referred to as the Cascade Playground for the two waterfalls in the play area. To the right of the man and girl, two men stand along the railing of the goldfish pond, likely admiring the recently added goldfish. Just behind them, a moored rowboat waits for a visitor to paddle it around the pond.

AMERICAN ASSOCIATION OF PARK SUPERINTENDENTS VISIT HUBBARD PARK. The American Association of Park Superintendents held its 1904 convention in New Haven and Meriden. The culminating event of the three-day convention was a visit to Hubbard Park on June 16, 1904, later remembered as Hubbard Park Day. As guests of Walter Hubbard (third from right), the attendees

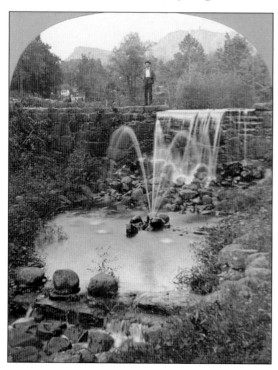

HUBBARD PARK FOUNTAINS. The fountains that adorn the Hubbard Park ponds are some of the park's most iconic features. Part of Walter Hubbard's original design for the park, each breathtaking fountain is gravity-fed and requires no pumps or electricity. In this early photograph, a man poses by the rock wall and waterfall at the Park Way entrance as a fountain sprays water and mist into the air.

HUBBARD PARK.
JUNE 18-04.

were taken to different parks throughout the city and ended their tour at Hubbard Park. Upon their arrival, they ascended West Peak for a luncheon at Katelyn Cottage, the summer residence of William and Jennie Catlin. More than 40 park superintendents and area representatives from several eastern states were present. (Courtesy of the Meriden Historical Society.)

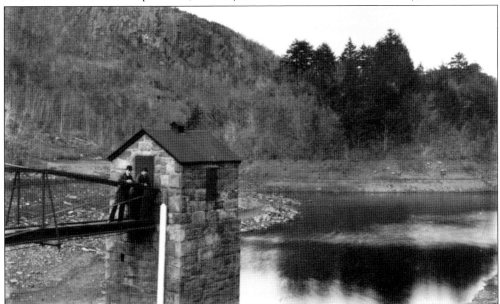

MERIMERE ECHO. Here, two well-dressed men pose on the planks of the Merimere Reservoir gatehouse bridge looking over the low-level waters of the reservoir. Mine Island is visible to the right, and the base of East Peak is in the background. The natural canyon surrounding the reservoir provided entertainment for many, being a prime area to hear echoes.

HUBBARD PARK FOOTBRIDGE. Walter Hubbard spared no expense when it came to the construction of his park. In 1898, he funded this ornate iron bridge for the lower pond. It was likely designed by David Stuart Douglass and built by Patrick J. Quigley. In this photograph, six women pose on the distinctive bridge during Meriden's 1906 Centennial Week celebrations. This particular iron bridge was one of three originally installed in the park and is the only one that remains today. (Courtesy of the Meriden Historical Society.)

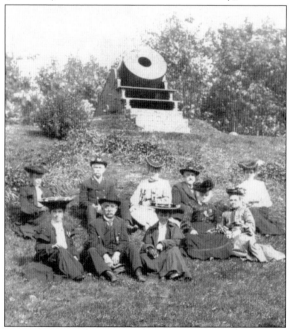

GAR IN HUBBARD PARK. Here is a 1909 photograph of a few members of Meriden's Grand Army of the Republic (GAR) Merriam Post No. 8 and their wives near the mortar. The GAR was a national fraternal organization composed of Union veterans from the Civil War. They were responsible for establishing Decoration Day, which later evolved into Memorial Day. (Courtesy of Allen Weathers.)

EARLY-20TH-CENTURY FASHION IN THE PARK. The industrial revolution made it possible for people to afford the latest fashion. It also allowed them to dress more evenly, despite their finances, as style trends began to be marketed at a much faster pace. Here, young park visitors, each sporting fashions of the day, pose with the Grecian Temple in the background.

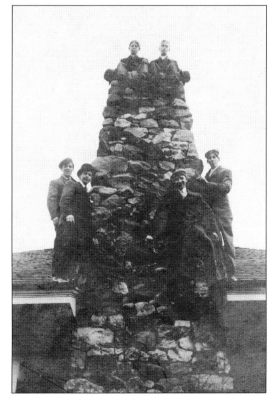

CHILDREN AT PLAY UPON THE HUBBARD PARK WAITING STATION. Walter Hubbard knew that it was important to have a trolley stop at Hubbard Park with a waiting station that was visually appealing and in keeping with the park's rustic design. Designed by David Stuart Douglass and built by Patrick J. Quigley, the Hubbard Park waiting station incorporated materials found within the park, in addition to stones from the nearby Sievert and Runge family farms on Johnson Avenue. Here, young men climb the waiting station chimney, built of stones from nearby farms.

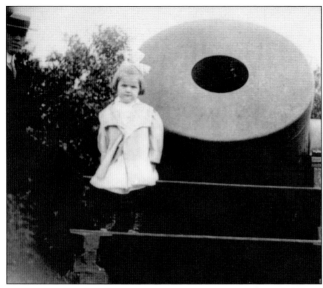

PRIVATE EXHIBITION OF MERIDEN FILMS. In August 1912, the Crystal Theatre and Meriden Airdome provided a preliminary viewing of the first moving pictures of Meriden. Police chief Charles B. Bowen, fire chief John F. Donovan, several newspaper reporters, and invited guests were present. The films showed city hall, Hubbard Park, Bradley Boulevard, the Lewis Avenue playground, and several other iconic places throughout the city. The segment from Hubbard Park included footage of this young girl posing with the Civil War mortar.

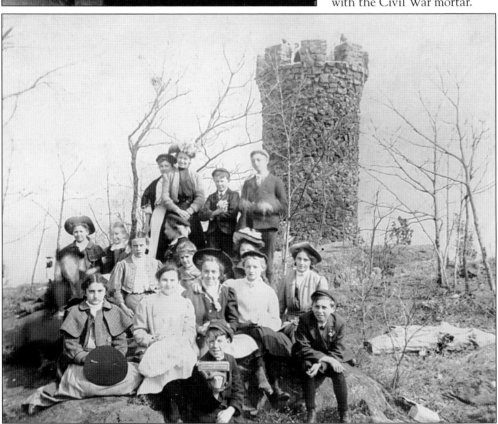

GATHERING AT THE TOWER. By the 1910s, large family gatherings of extended relatives were commonplace in Hubbard Park. Many would take the trolley to the park and walk the trails to Fairview Point. There, families would picnic beside the Fairview Observatory and enjoy the scenic views before venturing up to Castle Craig Tower on East Peak. Here, a group of children poses in front of the tower.

CHILDREN ON BRIDGE. This c. 1920 photograph shows four children standing on an iron bridge that once stood near the Park Way entrance to Hubbard Park. This image would be only a single snapshot of a kid's day in Hubbard Park. Fishing, hiking, and ball games throughout the park were often enjoyed during this time. The iron bridge seen here has since been replaced by a more rustic timber bridge.

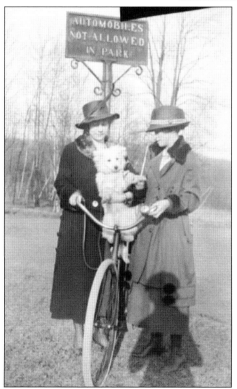

AUTOMOBILES IN THE PARK. Around the time of Walter Hubbard's park donation in 1900, early automobiles were appearing around Meriden. For a brief time, these cars were allowed within the park boundaries, but shortly thereafter, Henry T. King, Hubbard's legal counsel, drew up new regulations preventing automobiles from entering the park. In 1927, despite public resistance, automobiles were once again permitted into the park. (Courtesy of Allen Weathers.)

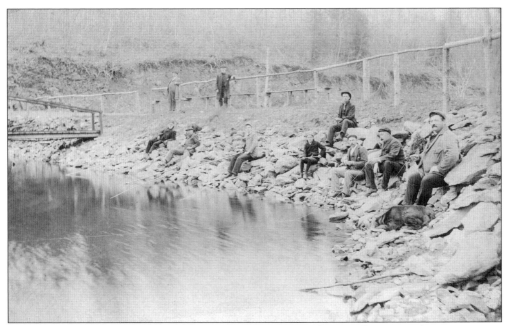

FISHING AT MERIMERE RESERVOIR. In this early-20th-century photograph, area residents enjoy some recreational fishing alongside the Merimere Reservoir. By this time, leisure activities like fishing were growing in popularity among the middle and lower classes. Although illegal today, reservoir fishing was a common activity over a century ago. (Courtesy of the Meriden Historical Society.)

PHOTO OPPORTUNITY AT THE FLORAL CENTERPIECE. This unique floral arrangement was the centerpiece to the pavilion turnaround that stood beside the Hubbard Park Grecian Temple for over half a century. For most park visitors, this beautiful landscape provided a decorative and playful background for photographs, as seen here with these three boys posing happily in the early 1900s. (Courtesy of Allen Weathers.)

COUPLE POSE AT HUBBARD PARK RAVINE. On June 16, 1907, Ida and Oscar Straub (left) and newlyweds Ida and Otto Schulz (right) sit along the stone-faced slopes of a ravine in Hubbard Park. The wooden footbridge was constructed of fallen park timbers, a suggestion from John C. Olmsted in his letters to Walter Hubbard in 1898. (Courtesy of Marion Schulz Muskiewicz.)

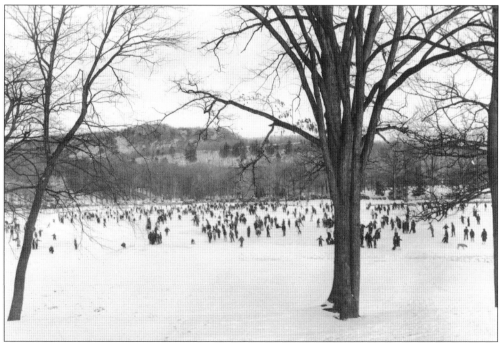

ICE-SKATING ON MIRROR LAKE. Skating on Mirror Lake is a tradition as old as, if not older than, Hubbard Park itself. When the park was under construction in the late 1890s, Mirror Lake was already considered a suitable location for ice-skating because of its freezing conditions. Skating at Mirror Lake remained a popular winter pastime for most of the 20th century. (Courtesy of the *Record-Journal*.)

FREDERICK W. KILBOURNE. Around 1920, Meriden resident Frederick W. Kilbourne led a small group of men in extending and fully documenting Hubbard Park's footpaths. A few years later, Kilbourne conceived the idea of a single trans-Connecticut trail, which he later dubbed the Trap Rock Trail. Aside from his hiking interests and trail expansion efforts, Kilbourne was an associate editor of *Webster's International Dictionary*.

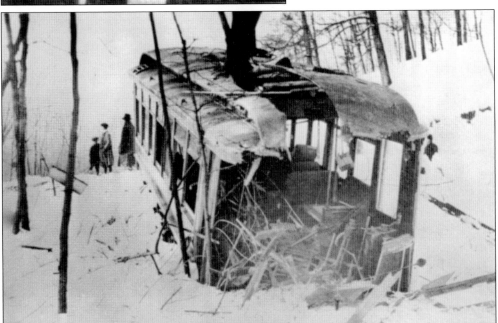

TROLLEY WRECKS AT HUBBARD PARK. By and large, trolleys were a safe, comfortable, and economical means of transportation, but they were not foolproof and were at risk for accidents. One such accident occurred in February 1921 when this trolley car ran off the rails while traveling down Southington Mountain and plunged into Hubbard Park's southwestern woods.

Six

A Renaissance for Hubbard Park

Although the Great Depression and World War II were defining events of the mid-20th century, bringing many hardships to the country, this period generated great community pride in Meriden and brought new improvements to Hubbard Park.

By the start of World War II in 1939, Meriden had a long-established industrial economy and history. Because of the city's industrial and patriotic contributions to the nation and war effort, Meriden was recognized as the Nation's Ideal War Community in 1944 by the War Manpower Commission.

James. J. Barry was appointed superintendent of parks after the untimely death of his predecessor, Donald Robison, who was drafted and killed a few years prior. Under Barry, the park quickly flourished, especially with his innate concern for the park's landscape.

Meriden's industrious spirit and the leadership of Barry brought about the greatest decades of change the park had seen since its creation. A park renaissance had begun.

Overseas, the Germans were deeply involved in northern Europe, especially in Holland, and had commandeered most of the food supply. In order to meet their nourishment needs, the Dutch began eating flower bulbs. Since Holland raised flower bulbs to sell all over the world, there were plenty on hand. They had hoped that they would be able to digest daffodils, a plant that they had an ample supply of, but they got very sick. At the end of the war, the poor, sickened country relied upon its major source of income—selling bulbs—to generate revenue. The Dutch quickly began sending salespeople to the United States to restart their economy. One of these salesmen introduced Barry to the idea of daffodils in the park.

The first 1,000 daffodils were planted at the park in 1949. It was such a success that four years later, Meriden's first Daffodil Day was celebrated with 180,000 of the bright yellow flowers along the shores of Mirror Lake.

Between 1948 and 1958, an infusion of new buildings and activity areas were constructed, including a greenhouse in 1948, a swimming pool in 1950, a wading pool in 1954, a band shell in 1956, and a birdhouse in 1958, along with tennis courts, swings, and seesaws.

THREE ARTISTS PAINT TOGETHER. During the Great Depression of the 1930s, local artists Frederick Matzow, John Backstrom, and Artie Watts frequently painted together in Hubbard Park. Each would bring his own paints and three canvases. Once they had established the subject of that day's work, each artist worked all three of his canvases simultaneously, correcting details as they went. Pictured is a painting by Watts entitled *Reservoir Road.* (Courtesy of the Meriden Public Library.)

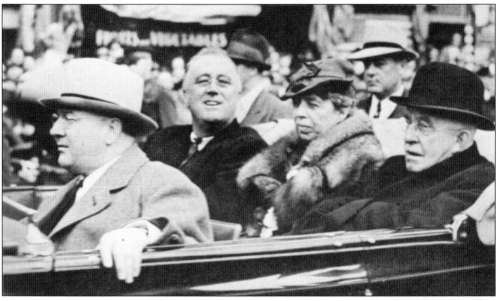

VISIT FROM THE PRESIDENT. Of the 13 presidents who have visited Meriden, only one reached Hubbard Park. On the morning of October 22, 1936, Pres. Franklin Delano Roosevelt visited Meriden while campaigning for his second term. During his visit, he traveled a five-mile route through the heart of the city and to Hubbard Park before heading to Waterbury. Roosevelt (pictured second from left) was accompanied by his wife, Eleanor, and escorted by Sen. Francis T. Maloney of Meriden (far left) and Gov. Wilber L. Cross (far right).

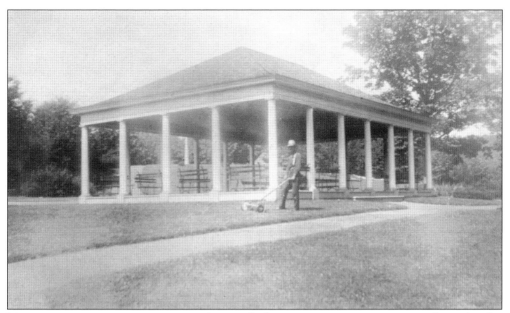

MOWING THE LAWN. James J. Barry is known for his 30-year tenure as superintendent of parks, from 1941 to 1972. However, he began his career with the Meriden Parks Department years earlier as a laborer. In this c. 1938 photograph, Barry is mowing the lawn and tidying up the landscape around the Grecian Temple, with the Civil War–era mortar visible in the background through the columns. Laborers like Barry were essential for maintaining the park's landscape for visitors, gatherings, special events, and celebrations.

MAJ. DONALD T. ROBISON. Maj. Donald T. Robison was the superintendent of parks leading up to the start of World War II in 1939. In 1940, Robison was called to military duty and was killed four years later during combat in the Pacific. He was posthumously awarded the nation's third-highest honor, the Legion of Merit. He is memorialized with a plaque on a boulder on the south side of the park near the current exit.

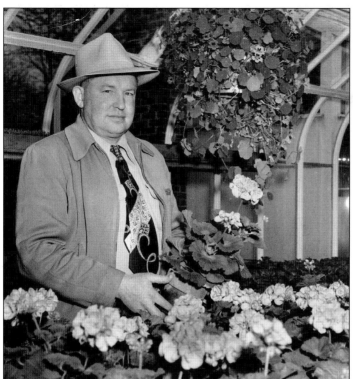

JAMES J. BARRY. The Hubbard Park daffodils, a greenhouse, and the construction of the iconic band shell are just three of the many legacies of James J. Barry's 40-year tenure as superintendent of parks. Seen here with geraniums in the Hubbard Park greenhouse in 1951, Barry held the position of superintendent from 1941 until his retirement in 1972, but his career with the Meriden Parks Department began in 1933. (Courtesy of James J. Barry.)

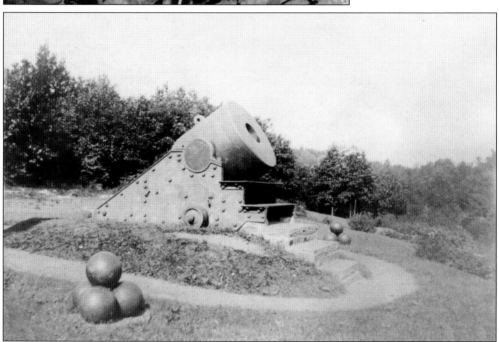

DONATING THE MORTAR TO THE WAR EFFORT. On November 17, 1942, Mayor Francis R. Danaher announced his intention to contribute the Civil War–era mortar and cannonballs to the World War II effort. After the mortar was removed from the park, a live cannonball at risk of exploding was discovered. The cannon that stood outside city hall was also donated to the war effort.

MURDER WEAPON FOUND IN MIRROR LAKE. On Tuesday, December 4, 1946, Mirror Lake was drained to search for vital evidence in connection with the murder of James A. Leach, an assistant manager at the local W.T. Grant variety store. After three days of searching, a gun and two boxes of ammunition were recovered from the bottom of the lake. Two arrests were made following the investigation.

MUSKRATS IN THE PARK. In this photograph, a man is rowing a boat in the waters behind the Hubbard Park Grecian Temple. Years later, this part of the park became infested with muskrats. Common in Connecticut, it was nearly impossible to rid the rodents from the park. Superintendent Barry and his workers had to place traps daily. (Courtesy of the Meriden Historical Society.)

BEN HOMER. At the age of 11, Meriden resident Benjamin Hozer joined the Meriden City Band, which often practiced and performed in the Hubbard Park Grecian Temple. Hozer was known professionally as Ben Homer and had an active career in songwriting, traveling with Benny Goodman, Count Basie, and other big bands. His most famous composition was "Sentimental Journey." He was inducted into the Meriden Hall of Fame in 1984.

FUTURE TENNIS LEGEND PRACTICES IN THE PARK. Pictured here in her high school portrait, Meriden native and soon-to-be tennis superstar Lois Felix often practiced with her brother on the Hubbard Park tennis courts as a teenager. Her career culminated with her being ranked the number eight women's player in the nation in 1954 by the US Lawn Tennis Association. She was inducted into the Meriden Hall of Fame in 1979 and the New England Tennis Hall of Fame in 1990.

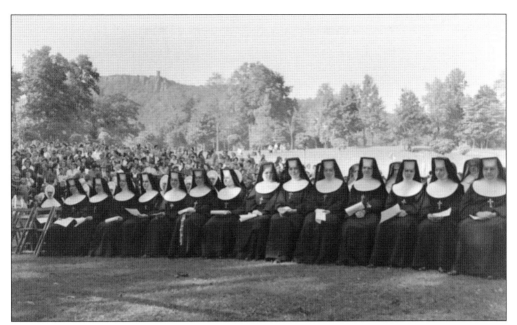

RELIGIOUS CEREMONY IN THE PARK. Hubbard Park has hosted many religious ceremonies over the years. In this 1950 photograph, the Sisters of St. Joseph of the Third Order of St. Francis sit attentively during a special Roman Catholic service. These women of faith, comprised mainly of teachers, still serve the sick and the poor. (Courtesy of Allen Weathers.)

THE LIONS CLUB SWIMMING POOL. The Lions Club swimming pool attracts many to Hubbard Park during the summer. The 200,000-gallon pool was built in 1950 by the Lions Club with aid from the city. A room below the 100-foot-by-42-foot pool circulates and filters the water every four hours. The pool was closed in 1989 due to neglect and disrepair but was reopened in 1993. (Courtesy of the *Record-Journal*.)

DINOSAUR TRACKS. Over the years, numerous donations of dinosaur tracks have been bestowed upon the park. After a heavy rainfall on March 26, 1953, local poultry dealer Rennock R. Muenchow discovered tracks during construction on Yale Avenue. Superintendent of parks James J. Barry requested that the 4.5-foot-by-11.5-foot sandstone slab be transferred to Hubbard Park. It was later discovered that the tracks belonged to a very early dinosaur that measured about 47 feet long.

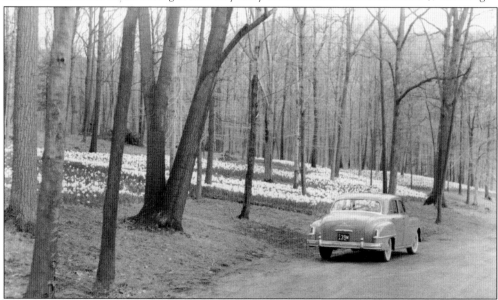

DAFFODIL DAY. On April 19, 1953, Meriden residents were invited to view 150,000 daffodils in bloom at Hubbard Park. Mayor William J. Cahill issued the first Daffodil Day proclamation that day, making the daffodil the city's official flower. In the ensuing decades, Daffodil Day evolved into the annual Meriden Daffodil Festival, a weekend-long celebration that attracts thousands of visitors to the park for a parade, musical entertainment, a craft fair, rides, food, and more than 600,000 daffodils on display throughout park. (Courtesy of the *Record-Journal*.)

HUBBARD PARK ZOO. In 1956, the Soroptimist Club constructed a modest zoo just east of Notch Road. It featured deer, llama, and several other animals. Although it was displaced by the construction of Route 66 in the 1960s, a smaller zoo continued to operate. In later years, park visitors began attacking the animals, diminishing the population and causing the zoo to close. The final building in the zoo complex was demolished in 1996.

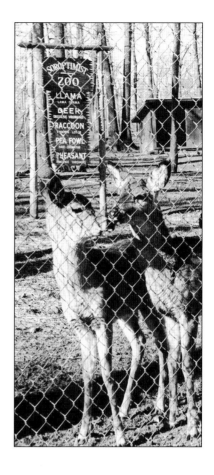

PENNY AND COBBY. Hubbard Park's first swans were donated in 1956 by local businessman, lifelong conservationist, and former lieutenant governor Roy C. Wilcox. They arrived at the park just weeks before this July 28, 1956, photograph was taken. The swans were nameless when they arrived, so the *Meriden Record* sponsored a naming contest. Penny and Cobby were the winning submissions. (Courtesy of the *Record-Journal.*)

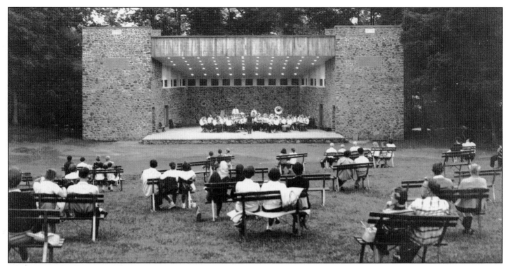

ADDITION OF A PARK BAND SHELL. The initial recommendation for a music shell for concerts and performances in Hubbard Park was made in 1953. Just three years later, the iconic, rustic-looking band shell was complete, built of local stone and traprock combined with natural wood to keep with Hubbard's original aesthetics for the park. The band shell includes a covered open-air performance stage with dressing rooms on either side The band shell was named in honor of park superintendent James J. Barry in 1986. (Courtesy of the *Record-Journal*.)

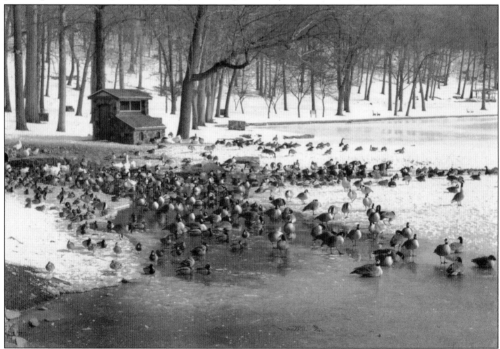

HUBBARD PARK DUCK HOUSE. One of park superintendent Barry's special interests was the park's large duck population. The duck house along Mirror Lake provides both a shelter and an enclosed breeding haven for the park's flock of mallards, drakes, and wood ducks. This photograph by the late Paul Hansen of Meriden shows the many ducks that call Hubbard Park home, even during the winter.

DAFFODILS IN THE PARK. Sitting among the daffodils, Kathleen Ann Murray is jokingly caught in the act of pilfering a daffodil by Officer Joseph McManus of the Meriden Police Department. A scolding may have followed but no arrests were made in this staged June 1956 photograph taken in Hubbard Park in celebration of Meriden's 150th anniversary. Hubbard Park hosted many sesquicentennial celebrations that year. (Courtesy of the Meriden Historical Society.)

WALTER HUBBARD PLAQUE IN HUBBARD PARK. In the late 1950s, local residents noticed that there was no formal monument in the park that honored its donor, Walter Hubbard. In October 1959, it was announced that a bronze plaque recognizing Hubbard's generosity and foresight would be placed in the park. Roy C. Wilcox, who donated the park's first two swans three years earlier, paid for the plaque and superintendent Barry selected the most natural boulder on which to mount it.

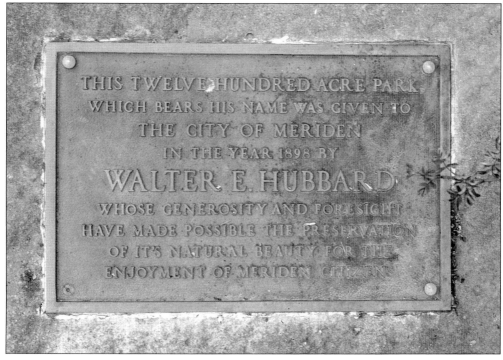

THIS TWELVE HUNDRED ACRE PARK
WHICH BEARS HIS NAME WAS GIVEN TO
THE CITY OF MERIDEN
IN THE YEAR 1898 BY
WALTER E. HUBBARD
WHOSE GENEROSITY AND FORESIGHT
HAVE MADE POSSIBLE THE PRESERVATION
OF IT'S NATURAL BEAUTY FOR THE
ENJOYMENT OF MERIDEN CITIZENS

ICE FOUNTAINS. Cold snaps during the winter months sometimes cause large ice mounds to form around Hubbard Park's gravity-fed water fountains. During prolonged periods, the spray from the fountain can create mounds more than 10 feet high with dangling icicles forming monster ice sculptures that kids enjoy playing on. (Courtesy of Leigh Trostel.)

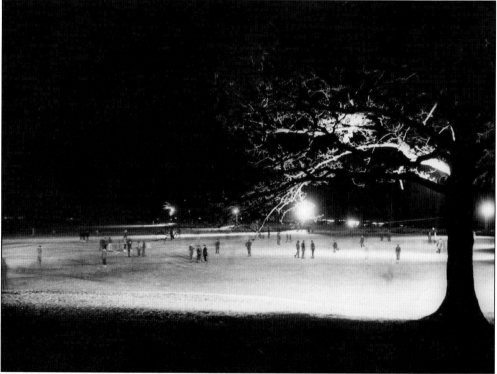

NIGHTTIME ICE-SKATING ON THE LAKE. During the 1950s, Mirror Lake was a popular place to go ice-skating in the winter. Lights were strung to illuminate the lake for nighttime skating, and the icy surface was thronged with people whenever the conditions were ideal. The nearby Hubbard Park Skate House, once the park's waiting station, was a comfortable place to lace up before going on the ice. In addition to traditional ice-skating, barrel jumping and Crack the Whip were typical activities on the ice.

Seven

A PERIOD OF CHANGE

Hubbard Park has always had its challenges, but the second half of the 20th century brought exceptional changes, some of which had an irreversible impact.

As the park's popularity spread across the state, Meriden residents had to contend with hundreds of out-of-town visitors each weekend, many of whom would come early to secure the best picnic and leisure spots. Meriden residents became disenchanted with how the park was being used and by whom. In 1960, Hubbard Park car stickers and swimming tags were issued to allow only Meriden residents into the pool on weekends and holidays.

Increased use and growing age took their tolls on the park. The old Merimere Reservoir gatehouse, wading pool, goldfish pond, and new greenhouses fell into disrepair, and the once iconic Steps to Fairview disappeared. The road to the peaks was characterized by a dilapidated fence along the reservoir and hazardous pavement. Aging infrastructure was coupled with deliberate vandalism: litter throughout the park, teenagers driving cars into wooded areas and abandoning them, broken and stolen playground equipment, and visitors abusing zoo animals. Not even Castle Craig Tower was unscarred, the traprock exterior being tagged with graffiti.

The most drastic change since the park's creation came in 1969 when the state seized 46 acres of land through eminent domain for the construction of 6-A Alternate, later designated Connecticut Route 66 and then Interstate 691. The highway, routed through the park against the protests of Meriden residents, separated the lower park from the Merimere Reservoir and East and West Peaks. Construction cut off trails and required removal of a beehive spring, and Mirror Lake was referred to as "Hubbard's Chocolate River" because of dirt from construction that washed into the water. Salt and oil-based contaminants polluted the park's waterways, rendering the once clear spring water undrinkable. Heavy machinery interrupted the peaceful atmosphere and forever changed the landscape of Hubbard's original park.

By the late 1970s and 1980s, action was required to address these problems. A caretaker position was created to provide around-the-clock, on-site security and maintenance. The Department of Parks and Recreation began enforcing park rules and monitoring vandalism with the support of the Meriden Police Department, which later approved a five-day-a-week park patrol.

Even this difficult period in Hubbard Park's history had a silver lining. Crowds still visited for ice-skating, a bicentennial celebration, fishing, and even a few alleged UFO sightings. It was a period of great transition that shaped the park of today.

HUBBARD PARK

19 68

Meriden, Conn.

HUBBARD PARK STICKERS ISSUED TO RESIDENTS. Mid-20th-century improvements to Hubbard Park attracted many out-of-town visitors to the park. In the summer of 1960, the park became inundated with non-residents traveling to use its facilities. In response, the city began issuing park passes like this one to residents through tax bills or at the park and required the passes on weekends and holidays. Swimmers were also required to have special tags to use the pool. (Courtesy of Dean Santor.)

FREDERICK MANDEVILLE. Over three decades, Frederick Mandeville (pictured) served the city and its parks. He worked alongside superintendent James J. Barry in 1954 and a decade later was named the director of recreation. He held that position until 1967, when he was appointed director of the newly combined Department of Parks and Recreation. Mandeville retired in 1980 and died eight years later in Meriden. (Courtesy of the *Record-Journal*.)

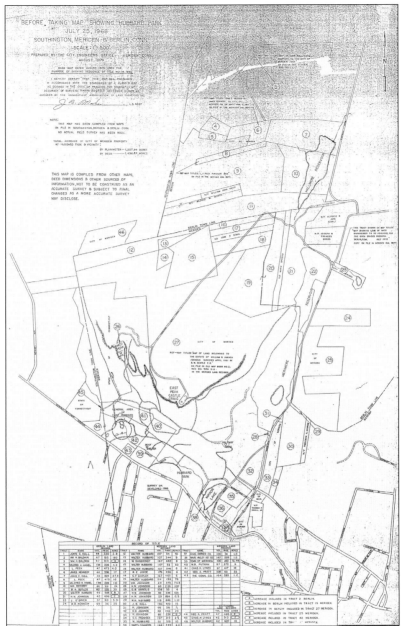

EMINENT DOMAIN DIVIDES THE PARK. In the early 1960s, rumors began about plans for a state highway that would pass through Meriden and divide Hubbard Park. Residents emphatically resisted this plan. Other routes were proposed, but something was wrong with each of them. Despite local opposition, the state succeeded in acquiring the land through eminent domain in the late 1960s and offered Meriden just $206,000 for the 46 acres used for the interstate. The city sued the State of Connecticut with the support of two professional appraisals of the Hubbard Park land, one for $2.3 million and the other for $5.4 million. The case moved slowly until it landed in court in 1980. The state offered to settle by handing over 46 acres of its own land atop West Peak. This 1968 map shows the sequence of Hubbard Park land acquisitions and the layout of the park prior to the construction of the highway.

AUTOMOBILES IN THE RAVINE. Not far beyond the current footbridge over I-691 that connects to the trail to Castle Craig Tower sits a deep ravine once filled with water flowing from East and West Peaks. This gully claimed a number of cars after foolish teenagers attempted to recklessly drive their vehicles through the woods and toward the tower. These cars sat abandoned in the ravine for decades until the remnants of rusted frames and broken parts were finally removed by the city.

STEPS TO FAIRVIEW. The original path to Fairview Point was destroyed by the highway construction. These Steps to Fairview were probably an early convenience along a steep trail; however, the rustic stairs completely disappeared over time. The steps were at the top of the path that started behind the Spring House, just north of Mirror Lake.

AMERICA'S 200TH ANNIVERSARY IN HUBBARD PARK. Meriden's bicentennial committee staged a series of events in Hubbard Park to celebrate the American bicentennial in 1976. On June 6, the park hosted the Bicentennial Wagon Train Pilgrimage (above), an entourage of covered wagons that traveled across the country and stopped in Meriden for two days. Park visitors provided a less-than-warm welcome for the wagon train, throwing stones at the pioneer reenactors, setting off firecrackers near the horses at night, and stealing valuables from the wagons. The following month, bicentennial celebrations continued with a Civil War reenactment and the liftoff of the Connecticut Bicentennial Ascension Balloon (right). Crowds gather below the tethered balloon as it rises above the ground in the early morning of July 24, 1976.

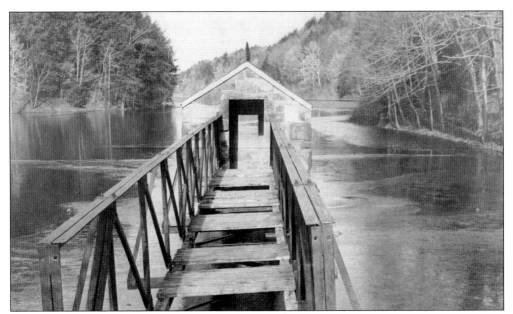

MERIMERE RESERVOIR GATEHOUSE FALLS INTO DISREPAIR. By the 1970s, the Merimere Reservoir gatehouse, the small stone building that pumped water from the southern end of the reservoir, was in drastic disrepair. This photograph shows the gatehouse with missing walkway boards and missing doors on the building itself. A few years later, the gatehouse was removed altogether. (Courtesy of the Meriden Public Library.)

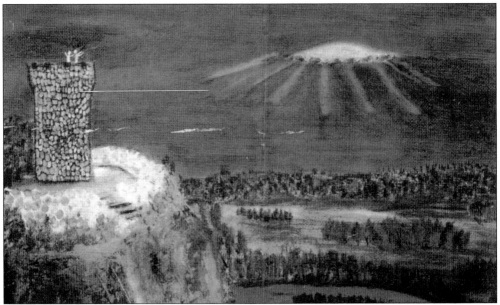

UFO SIGHTINGS IN AND AROUND THE PARK. In July 1978, numerous residents claimed to witness an unidentified flying object in Meriden, primarily in Hubbard Park. Although claims of UFOs had been made previously, these particular sightings were the subject of multiple newspaper articles and various documentaries, including the television program *Lost Evidence*. Some supernatural enthusiasts believe that Castle Craig Tower may be a conduit to another world. (Courtesy of Rick Messina; painting by Ellen Messina.)

VANDALISM BECOMES APPARENT. In the early 1980s, Craig Schroeder (pictured) became Meriden's director of parks. He and the city undertook an aggressive campaign to enforce strict safety measures in response to 325 arrests between April 4 and May 9, 1983, for violation of park rules. Further vandalism and unruly behavior led to the ultimate closure of the Reservoir Avenue entrance into Hubbard Park. (Courtesy of the Meriden Public Library.)

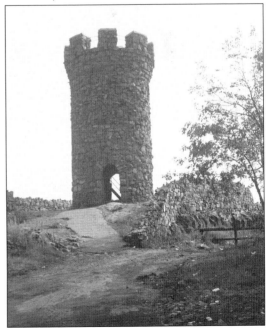

CASTLE CRAIG TOWER IS NOT FOR SALE. After the Meriden Chamber of Commerce selected Castle Craig Tower as its symbol for a promotional campaign in 1980, the landmark was quickly seen by thousands of people across the country. In response, a Cleveland businessman was so taken with the tower that he called Mayor William Tracy to inquire about purchasing the monument. His proposal was to disassemble the tower piece by piece and reconstruct it on his 10-acre estate in Ohio. Fortunately, his proposal was denied.

VIOLENCE TOWARD ANIMALS IN THE HUBBARD PARK ZOO. Editorial cartoonist Frank Lamphier's pen and ink illustrations graced the pages of the Meriden *Record-Journal* for over 60 years. Known as "Lamp," he often depicted Hubbard Park in his cartoons. In this illustration, he acknowledges the tragic cruelty toward the animals of the Hubbard Park Zoo. The continued animal abuse ultimately led to the zoo's permanent closure.

THIN ICE IN HUBBARD PARK. Hubbard Park workers once hand shoveled Mirror Lake during the snowy winter months to create a safe ice-skating surface for visitors. These workers also verified that the ice was thick enough to handle the weight of many skaters. With the advent of snow plows, trucks could be used to clear the ice, replacing the laborious task of shoveling. Unfortunately, some trucks were too heavy and fell through to the icy water below, as seen in this photograph. (Courtesy of Bruce Rovinsky.)

FISHING AT MIRROR LAKE. Every spring, kids of all ages flock to Hubbard Park for fishing at Mirror Lake. For years, fishing was restricted to children ages 14 and under, and city law required young anglers to be accompanied by a parent or guardian. This law was overturned in March 2013, and today, the lake is stocked with fish by the state. (Courtesy of the *Record-Journal*.)

VANDALISM STRIKES THE GREENHOUSE. Once a bustling floral sanctuary where superintendent Barry and his successor, Ken Hourigan, tended to a variety of flowers, the Hubbard Park Greenhouse was a key reason for the beautiful flowers across the park. But as time passed, it deteriorated. This 1986 image of the 42-foot greenhouse shows a heavily vandalized structure. (Courtesy of the *Record-Journal*.)

NEW HUBBARD PARK CARETAKER POSITION. After the stone caretaker's residence became vacant, it was evident that additional park security and maintenance were needed. After some debate, the position of Hubbard Park caretaker was created. Dominic Mazzone was the first to hold this position beginning in 1979 and was succeeded by Joseph Oblon (pictured) in 1986. The caretaker's duties included maintaining order within the park and opening and closing the gates on the road to the reservoir at dusk. After Oblon's death years later, the position was eliminated.

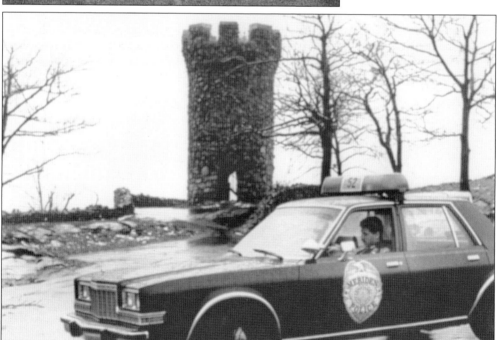

POLICE PRESENCE AT HUBBARD PARK. After multiple incidents of vandalism in the park, local officials approved a five-day-a-week patrol of Hubbard Park. In 1986, Officer Ronald J. Tremblay, also known as "Ranger Ron," was assigned to park patrol. A 16-year veteran of the Meriden Police Department, his job was to ensure the safety of park visitors, deter vandals, and protect park land, buildings, and wildlife. (Courtesy of the *Record-Journal*.)

Eight

CELEBRATING COMMUNITY

Hubbard Park and other city parks are core to Meriden's community life. Historically and today, the directors and employees of the Department of Parks and Recreation have brought an enthusiasm and devotion for these spaces that make them enjoyable for all visitors and appealing for celebrations. In the words of director Chris Bourdon, the parks and his department are "at the forefront of Meriden civic identity."

Hubbard Park has always been a highly active public space. But with the inception of the annual Meriden Puerto Rican Festival in 1967 and the annual Meriden Daffodil Festival in 1979 and their growing popularity over the years, the park became an exceptional venue for larger community events and celebrations. Both festivals continue today and have inspired the Black Expo and Black Heritage Festival, Independence Day fireworks and concerts, Festival of Silver Lights, Christmas in the Park, Fall Festival hayrides in October, community concerts in the Hubbard Park band shell, footraces to the Castle Craig Tower and West Peak, and more.

Walter Hubbard conceived and donated his park with the intent that it would always be a place for the people of Meriden, a public space where everyone could enjoy the landscape free of charge. Though some question whether events that sell concessions and generate profits are in line with Hubbard's original vision, such gatherings draw Meriden residents and out-of-town visitors to the city's most cherished park space and foster a deep appreciation for Hubbard Park. If Hubbard were alive today, he would be pleased by the masses of people who flock to his park for special occasions and community celebrations.

CITY OF MERIDEN
CONN.
06450

DEPARTMENT OF PARKS AND RECREATION

460 LIBERTY STREET April 11, 1978

Mr. Carter H. White, Publisher
Meriden Record Company
Crown Street Square
Meriden, Conn. 06450

Dear Carter:

As per your letter to Mayor Evilia, please be advised that the idea
of Meriden becoming the Daffodil Center of Connecticut is one that
previous Park and Recreation Commissions along with Mr. James Barry,
former Superintendent of Parks, have had.

I have taken the liberty to enclose a copy of a memorandum to Mayor
Evilia, dated March 16, 1978, and I sincerely feel that your idea
could become a reality and the proposed committee could be forma-
lized.

 Very truly yours,

 Fred

 Frederick C. Mandeville, Director
 Parks and Recre tion Department

FCM:ml

Enc.
cc: Mayor W.Evilia

ORIGINS OF THE MERIDEN DAFFODIL FESTIVAL. In a March 1978 letter to Mayor Walter Evilia,
Meriden Record Company publisher Carter White proposed that the city transform Daffodil
Day into something more. At the same time, the Meriden Expo was outgrowing its downtown
location, and the idea for one annual festival in Hubbard Park piqued peoples' interest. "Hubbard
Park has without doubt the best displays of daffodils every spring of any city or park in the state,"
White wrote. "We have lots to be proud of in Meriden, and the Hubbard Park daffodils are one
of the most striking examples. It would do credit to your administration to start such a permanent
program." As director of the Department of Parks and Recreation, Frederick C. Mandeville replied
to White on behalf of the city stating, "I sincerely feel that your idea could become a reality." The
Meriden Daffodil Festival began in 1979 as a community event but today it has become one of
Connecticut's premier celebrations. (Courtesy of the *Record-Journal*.)

DAFFODIL WEEK. In April 1979, six-year-old Heather Young was announced as the first Little Miss Daffodil in front of a crowd of 200 people in a rain-soaked Hubbard Park. In this brief ceremony, Mayor Walter Evilia also drew the name of Kathleen LeVasseur to be Daffodil Week's Senior Citizen. While rain dampened the beginning of the first Daffodil Week, the weather held out for the culminating parade with Young and LeVasseur proudly riding in a red convertible. (Courtesy of the *Record-Journal*.)

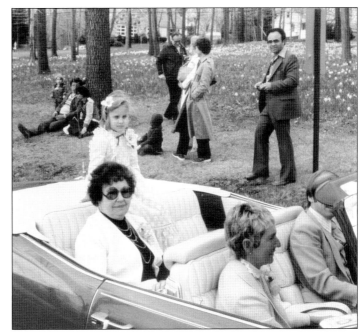

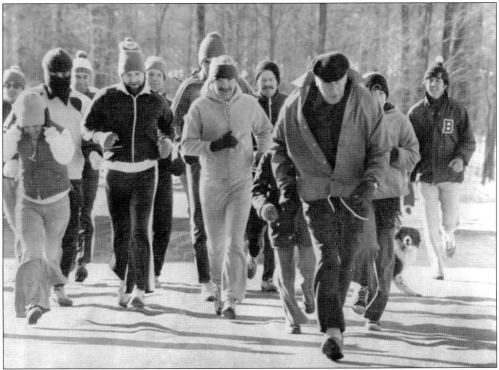

BERNIE JURALE MEMORIAL TRADITION RUN. In January 1970, Bernie Jurale celebrated his 70th birthday by running 3.1 miles to the summit of West Peak. A local science teacher, Jurale continued the tradition each January and was joined in subsequent years by some of his students. He made his last run to the summit in 1979, but his spirit and determination are memorialized each January with the Bernie Jurale Memorial Tradition Run. (Courtesy of the *Record-Journal*.)

MARK ZEBORA. Mark Zebora worked for the city for six years before beginning his 30-year tenure as director of the Department of Parks and Recreation. He will be remembered for setting Hubbard Park in a new direction following the difficult decades of the 1960s, 1970s, and early 1980s. He initiated unique celebrations such as Christmas in the Park and the Festival of Silver Lights, which are successful annual events today. He also helped to grow the Meriden Daffodil Festival, one of New England's most celebrated events. (Courtesy of the *Record-Journal*.)

FESTIVAL OF SILVER LIGHTS. Since 1988, Hubbard Park's annual Festival of Silver Lights holiday display has been a special community celebration. Come Columbus Day each year, park workers begin to untangle strands of lights, test bulbs, and review a lighting plan for the end-of-year spectacle. The park comes alive with over 350,000 lights hanging in trees, decorating buildings, illuminating wire animals and holiday figures, and replicating Meriden's landmark Traffic Tower and Castle Craig Tower. A tree and park lighting are held around Thanksgiving in November, and the festival continues through early January. (Courtesy of Lynne Cormier Vigue.)

JACKKNIFE. Hubbard Park was used as the setting for one of the scenes in the 1989 movie *Jacknife*. Starring (from left to right) Ed Harris, Kathy Baker, and Robert De Niro, the film told the story of a Vietnam War veteran trying to return to everyday life while suffering from post-traumatic stress disorder. *Jacknife* was adapted from the play *Strange Snow* by Stephen Metcalfe, a native of the neighboring town of Cheshire, Connecticut.

"CROSSROADS OF CT." In October 1993, Meriden became the first Connecticut town to be recognized on a special state license plate. Created in response to the successful Long Island Sound "Preserve the Sound" environmental plates sold the preceding year, the Meriden design featured the city's two Hubbard Park trademarks: the daffodil and Castle Craig Tower. Local artist Blaise Lamphier designed the plate and chose the tagline "Crossroads of CT" in reference to Meriden's intersecting highways.

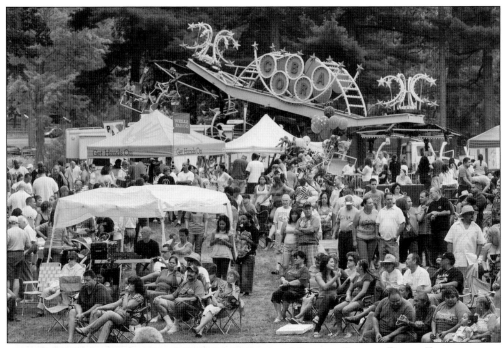

MERIDEN PUERTO RICAN FESTIVAL.
Hubbard Park hosts tremendous
independent community festivals.
Meriden's Hispanic culture is celebrated
each August at the annual Meriden
Puerto Rican Festival. Started in June
1967, the festival is an all-day event
showcasing Puerto Rican food, music,
entertainment, and dancing. It is
one of Meriden's largest community
celebrations and one of the largest
cultural festivals in the region.

BLACK EXPO IN THE PARK. The
Black Expo, later renamed the Black
Heritage Festival, was started in 1989
and held several annual events in
Hubbard Park. This daylong festival
promoted African American culture
and history and featured vendors, kids'
amusements, and live entertainment.
In this photograph, Marcia Cooper and
other members of the Mount Hebron
Baptist Church choir sing a gospel song
during Black Expo on June 20, 1998.
(Courtesy of the *Record-Journal*.)

MERIDEN BICENTENNIAL CELEBRATION AT HUBBARD PARK. Meriden celebrated its historic bicentennial in June 2006 with a week of activities commemorating the milestone. The culminating event was a concert in Hubbard Park with nearly 5,000 attendees, a smaller than expected crowd due to rain that afternoon. Meriden's own Robbie Hyman (pictured above at right) and his band the Hooters opened the celebration. Rock and roll legend Chuck Berry (right) was the headliner and performed in his signature dazzling red shirt and nautical captain's hat. Berry showcased many of his classic hits, including "Johnny B. Goode," "Memphis," and "You Never Can Tell."

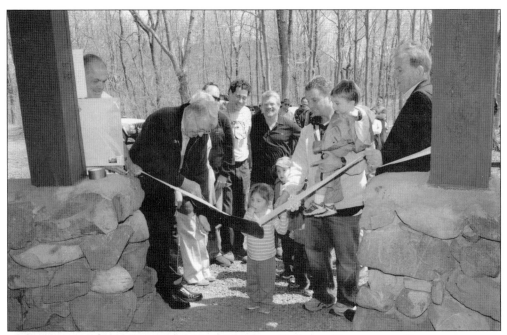

FAIRVIEW OBSERVATORY RESTORATION.
Volunteers helped restore the Fairview
Observatory, the Hubbard-era pavilion
and rest stop, in 2008 after years of
neglect and vandalism. Graffiti, beer
cans and liquor bottles, broken glass, and
litter were common inside and outside
the pavilion, and missing roof supports,
missing pillars, a worn roof, and ash from
illegal campfires all contributed to the
decay of the structure itself. While clearing
debris inside the observatory, volunteers
uncovered what may have been the
mounting posts for the Globe Hy-Power
binoculars, which were installed around
1933. (Courtesy of the *Record-Journal*.)

UNITY DAY CELEBRATION. This
November 14, 1992, photograph shows
(from left to right) Kira Murphy, Lisa
Parker, and Taryn Murphy sitting at the
edge of the park's wading pool gazing
up at an 18-foot lighted globe during
the Unity Day celebration at Hubbard
Park. The globe, positioned on top of the
goldfish pond, was just one of the many
lighted attractions during this popular
and unique festivity. Today, the globe is
a featured display in the Festival of Silver
Lights. (Courtesy of the *Record-Journal*.)

FIREWORKS CELEBRATION FOR INDEPENDENCE DAY. This 2015 photograph shows fireworks exploding over East Peak and Mirror Lake during the annual Independence Day celebration at Hubbard Park. Audiences of up to 10,000 attend the display each year, and an average of 1,500 explosive shells go off during the 30-minute performance. Many regard Meriden's fireworks display in Hubbard Park as one of the finest in Connecticut. (Courtesy of the *Record-Journal*.)

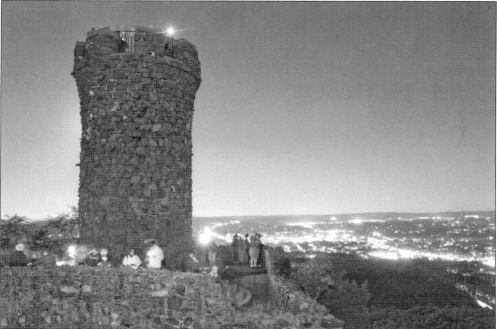

NIGHTTIME VIEWINGS AT CASTLE CRAIG TOWER. Meriden sparkles like a jewel as Castle Craig Tower looks over the valley in this nighttime photograph. In September 2013, residents were overjoyed to learn that Hubbard Park and Castle Craig Tower would stay open late once each month throughout the summer for full-moon viewings. Coordinated by the Department of Parks and Recreation, these rare nighttime viewing opportunities continue to attract hundreds of people to the top of East Peak. (Courtesy of the *Record-Journal*.)

ADVENTURE HOLLOW. Adventure Hollow is Hubbard Park's 13,000-square-foot, barrier-free playground. Built in memory of one-year-old Noah Bourdon, a toddler who died tragically on a city playscape, it serves as a wonderful recreation area for children of all ages with its fenced-in playscapes, swings, sensory garden, and sand-play area. Adventure Hollow replaced the original Hubbard Park playground that once stood between the waiting station and the wading pool.

CHRIS BOURDON. Chris Bourdon was first hired by the City of Meriden in 1998. He became assistant director of the Department of Parks and Recreation in 2014 and was elevated to director upon Mark Zebora's retirement in 2016. Today, he and the department are responsible for maintaining and improving the city's 25 parks and their facilities. For Bourdon, the job of maintaining the city's parks is one of great pride: "We want to continue the over 100-year legacy of the Meriden Parks Department being at the forefront of Meriden civic identity." (Courtesy of the *Record-Journal*.)

VIEWING THE SOLAR ECLIPSE AT CASTLE CRAIG TOWER. Crowds gathered at Castle Craig Tower on August 21, 2017, to witness a partial solar eclipse from one of the highest points in the region. This was not the first time an eclipse drew crowds to East Peak, though, as thousands of spectators flocked to the tower on the morning of January 24, 1925, eager to witness a total solar eclipse. (Courtesy of the *Record-Journal*.)

CHRISTMAS IN THE PARK. Christmas in the Park draws hundreds of families and community members to Hubbard Park each year for horse-drawn carriage rides, a tree-lighting ceremony, a Santa's workshop display in the park's waiting station, and a visit from Santa. Started in 1988 along with the Festival of Silver Lights, this celebration is a highly anticipated event. Here, sisters Emily (left) and Katie Anastasio pose with a snowman during the 2017 Christmas in the Park. (Courtesy of the *Record-Journal*.)

WILDLIFE IN THE PARK. Hubbard Park's woodlands are home to diverse wildlife. Deer and turkeys are the most common animals seen while hiking the park's trails along with a variety of snakes, which can be seen during the warmer months. In recent years, Hubbard Park became home to a small colony of exotic, colorful monk parakeets. A species of parrot, the monk parakeets migrated to the park from the southern United States decades after tens of thousands were imported from South America and escaped or were released. (Courtesy of Sandi Jacques/ Macaulay Library at the Cornell Lab of Ornithology.)

CORONAVIRUS PANDEMIC AFFECTS THE PARK. The coronavirus pandemic hit Connecticut in March 2020, causing the unthinkable cancellation of Hubbard Park's signature celebration of over 40 years—the Meriden Daffodil Festival. Under strict stay-at-home orders, residents flocked to Hubbard Park for a reprieve from their homes and to enjoy the outdoors. As a result, park visitors were monitored for social distancing. For the safety of all visitors, park attractions like the Adventure Hollow playground, the swimming pool, and Castle Craig Tower remained closed.

Nine

BEYOND THE PARK

The scenic Hanging Hills and their surroundings have been admired for centuries, both for their landscape and their potential for development. Eighteenth-century settlers like Daniel Johnson and James Hillhouse chose to settle and start farms in the valleys and on the mountains, later attracting others to cut trees, harvest ice from the lakes and from a rare ice cave, and establish industries. In the 19th century, manufacturers like Julius Parker and the Parker & Whipple Manufacturing Company constructed plants just outside the park's current boundaries on West Main Street, taking advantage of Crow Hollow Brook, which was powered by water from East and West Peaks. The Pullan brothers also recognized the business potential of the fresh spring water from the mountains and opened the Aurora Springs Bottling Works nearby. Even on South Mountain, opposite the Merimere Reservoir, the land was developed for a resort and bowling alley and later a match manufacturing company and community poorhouse. The landscape attracted people to the Hanging Hills, and where there are people, there will be enterprise.

Walter Hubbard was attracted to the natural beauty of the Hanging Hills, and his campaign to build a park sought to preserve, rather than develop, the land. However, his ambitious plan to develop an oasis for recreation and an escape from the booming industrial Meriden center ultimately attracted new development on the outskirts of the park. As he acquired land for the park in the 1880s and 1890s, residents purchased adjacent tracts for private homes and resorts, taking advantage of the scenery and views the mountaintops provided. Julius Katt opened an ice cream stand in 1889 directly across from the future Hubbard Park, perhaps hoping to capitalize on the traffic that would soon pass by. McHugh's Pavilion and later Craig Loch Manor opened to sell refreshments, sweets, and meals to crowds of parkgoers. These for-profit establishments seemed to stand in contrast to Hubbard's vision for a serene park free of development and concessions.

Whether pre-dating Hubbard Park or developed as a result of the park, the landscapes and businesses that surround Meriden's recreational gem are important to the context of the Hubbard Park story—the inspiration for and effect of its creation.

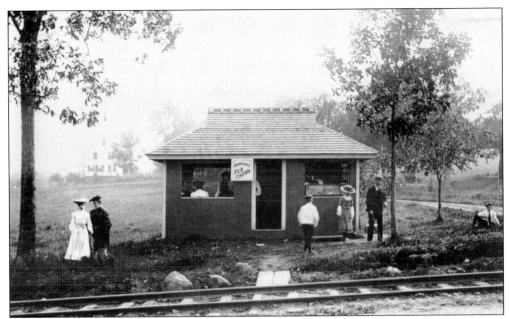

Julius Katt Ice Cream Stand. Established in 1889, the Julius Katt ice cream stand stood on the corner of Spruce and West Main Streets. After training as a confectioner in New York City, Katt relocated to Meriden and opened this seasonal venture across from the future Hubbard Park. Years later, he moved his business to Meriden's bustling downtown where it continued as a favorite dessert spot for decades.

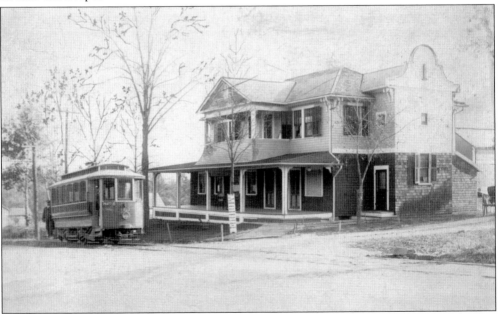

McHugh's Pavilion. In 1905, John A. McHugh of the California Wine Company opened this handsome building as a refreshment room, serving local residents and parkgoers. Known as McHugh's Pavilion, it served ice cream, confectioneries, and nonalcoholic temperance drinks. The pavilion stood opposite the park on the corner of Spruce and West Main Streets, at the end of the trolley line. (Courtesy of Allen Weathers.)

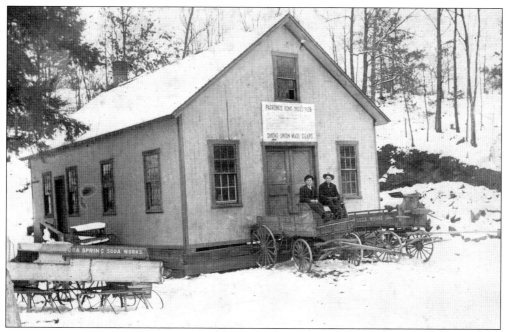

Aurora Springs Bottling Works. This Pullan brothers' soda-making outfit stood on the curve of West Main Street along the slope of Hubbard Park Hill. Accounts say that, depending on his mood, James Pullan would give visitors samples of the products. The proprietors, Aurora Springs Bottling Works, made and bottled soda, sarsaparilla, birch beer, and mineral water. (Courtesy of Allen Weathers.)

Lyra Park. During the first years of the 20th century, Lyra Park was a popular recreation and gathering spot. The subject of this early postcard, the park was located just southeast of Hubbard Park between today's West Main Street, Smithfield Avenue, and Johnson Avenue. The splendid Lyra Singing Society had a hall in the park, and meetings were held on Wednesday evenings.

CRAIG LOCH MANOR. Once the home of McHugh's Pavilion, Craig Loch Manor operated on the southeast corner of West Main and Spruce Streets directly across from Hubbard Park. Its Scottish name was derived from Crag Lake, an early moniker for Mirror Lake across the street. Craig Loch was a dining facility with a taproom, the Rathskeller, below. Curly Thomas, the original owner, ran the business for years until selling to the Meindl family. A fire in the mid-1970s closed the business permanently. The building no longer stands.

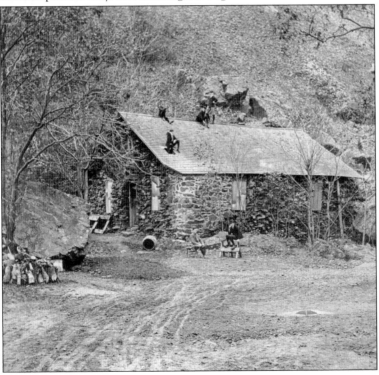

OLD BOWLING ALLEY. This stone building housed a tenpin bowling alley on the opposite side of South Mountain from the Merimere Reservoir. It was later purchased by Nathan Fenn for the Mountain House Match Works, and then repurposed as an annex to the Meriden Poorhouse, a city-run residence for the homeless.

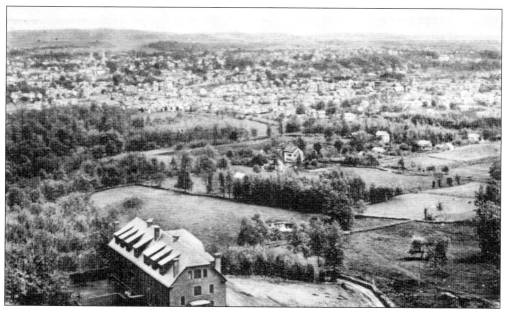

VIEW FROM SOUTH MOUNTAIN. This view overlooking Meriden was taken from Corrigan's Corner, a neighboring park area on South Mountain with a large farmhouse previously owned by James Hillhouse. Hillhouse raised elm saplings on this property, which were later removed to beautify the streets of New Haven, thus giving the city the nickname of "Elm City." He also represented New Haven in the Connecticut House of Representatives from 1780 to 1785 and later represented Connecticut in the US House of Representatives and Senate. (Courtesy of Brian Cofrancesco.)

COLD SPRING POORHOUSE. Local folklore says that on the southeastern side of South Mountain, just outside Hubbard Park, a cavity in the mountain once produced ice year-round. The Cold Spring Poorhouse (pictured) was built near the fabled cave in 1884 as a resort and later used as a home for the homeless and those in need. Most local residents did not venture up to the poorhouse nor the neighboring Undercliff Sanatorium built years later. Although arson destroyed the home in 1992, the location of the storied frozen cave remains a mystery.

CAT HOLE PASS. At the bottom of the gorge that divides South Mountain from Cathole Mountain lies a much-traveled road that separates Meriden and Berlin. This road, Cat Hole Pass, known as Chamberlain Highway today, has been used since the 18th century. Walter Hubbard believed that if he could expand his park to this route, he could easily attract new visitors. The connecting road he built is known as Reservoir Avenue.

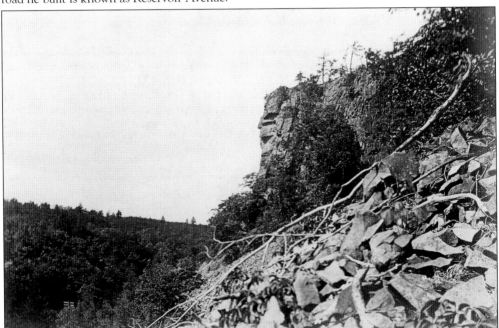

WASHINGTON'S FACE. Across from South Mountain, looking out over Cat Hole Pass, stares a craggy cliff known as Washington's Face. Projecting from Cathole Mountain, this peak once bore a resemblance to Pres. George Washington's profile. Time and weather have taken their toll on the formation, and in 1910, park officials attempted to artificially restore Washington's profile. Today, the cliff and eroded profile are still visible from Chamberlain Highway.

BIBLIOGRAPHY

Arms, H. Phelps. "Hubbard Park, Meriden, Connecticut." *Connecticut Magazine* Vol. 5, No. 2. February 1899: 66.

Atwater, Francis, compiler. *Centennial of Meriden, June 10–16, 1906, Report of the proceedings, with full description of the many events of its successful celebration; Old Home Week: Meriden, Conn., The "Silver City."* Meriden, CT: Journal Publishing Company, 1906.

Atwater, Francis. *Memoirs of Francis Atwater: Half Century of Recollections of an Unusually Active Life.* Meriden, CT: Horton Printing Company, 1922.

Baur, David and Agnes. *Frederick Matzow (1861–1938), Meriden's Artist-in Residence.* Meriden, CT: Konica Minolta Business Solutions, 2006.

Bishop, J. Leander. *Manufactures in Meriden.* Philadelphia, PA: Edward Young and Company, 1868.

Breckenridge, Frances A. *Recollections of a New England Town.* Meriden, CT: Journal Publishing Company, 1899.

Curtis, George Munson. *A Century of Meriden: A Historic Record and Pictorial Description of the Town of Meriden, Connecticut and the Men Who Have Made It, from Earliest Settlement to Close of its First Century of Incorporation.* Meriden, CT: Journal Publishing Company, 1906.

Davis, Charles Henry Stanley. *History of Wallingford, Conn., from its Settlement in 1670 to the Present Time: Including Meriden, Which Was One of its Parishes until 1806, and Cheshire, Which Was Incorporated in 1780.* Meriden, CT: self-published, 1870.

Franco, Janis Leach. *Meriden.* Charleston, SC: Arcadia Publishing, 2010.

Hill, Everett G. *A Modern History of New Haven and Eastern New Haven County*, Volumes 1 and 2. New York and Chicago: S.J. Clarke Publishing Company, 1918.

Hubbard, Walter. *Hubbard Park.* Meriden, CT: self-published, 1900.

Olmsted, John C. *Olmsted Letters.* Brookline, MA: 1898.

Perkins, G.W. *Historical Sketches of Meriden.* West Meriden, CT: Franklin E. Hinman, 1849.

Pynchon, W.H.C. "The Black Dog." *Connecticut Quarterly*, Volume 4. January 1898: 153.

Wendover, Sanford H. *150 Years of Meriden: Published in Connection with the Observance of the City's Sesquicentennial, June 17–23, 1956.* Meriden, CT: Meriden Sesquicentennial Committee, 1956.

Discover Thousands of Local History Books
Featuring Millions of Vintage Images

Arcadia Publishing, the leading local history publisher in the United States, is committed to making history accessible and meaningful through publishing books that celebrate and preserve the heritage of America's people and places.

Find more books like this at
www.arcadiapublishing.com

Search for your hometown history, your old stomping grounds, and even your favorite sports team.

Consistent with our mission to preserve history on a local level, this book was printed in South Carolina on American-made paper and manufactured entirely in the United States. Products carrying the accredited Forest Stewardship Council (FSC) label are printed on 100 percent FSC-certified paper.